HOW TO DRAW MANGA

Super Tone Techniques

HOW TO DRAW MANGA: Super Tone Techniques
by Unkaku Koyama

Copyright © 2000 Unkaku Koyama
Copyright © 2000 Graphic-sha Publishing Co., Ltd.

First published in 2000 by Graphic-sha Publishing Co., Ltd.
This English edition was published in 2002 by
Graphic-sha Publishing Co., Ltd.
1-14-17 Kudan-kita, Chiyoda-ku, Tokyo 102-0073 Japan

Cover drawing and coloring: Unkaku Koyama
Main title logo design: Hideyuki Amemura
Japanese edition Editor: Motofumi Nakanishi (Graphic-sha Publishing Co., Ltd.)
English edition Editor: Glenn Kardy (Japanime Co., Ltd.)
Cover and text page layout: Shinichi Ishioka
English translaion management: Língua fránca, Inc. (an3y-skmt@asahi-net.or.jp)
Foreign language edition project coordinator: Kumiko Sakamoto (Graphic-sha Publishing Co., Ltd.)

Distributed by
Japanime Co., Ltd.
2-8-102 Naka-cho, Kawaguchi-shi,
Saitama 332-0022, Japan
Phone /Fax: +81-(0)48-259-3444
E-mail: sales@japanime.com
http://www.japanime.com

First printing: July 2002

ISBN: 4-7661-1260-1
Printed and bound in China by Everbest Printing Co., Ltd.

HOW TO DRAW MANGA

Super Tone Techniques

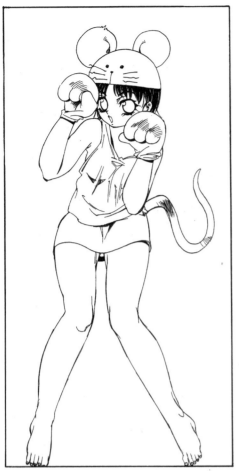

Tones add that "something special" to your characters.

My ink drawing came out OK.

Check it out!

But something seems missing.

① IC 663

② IC 61

③ Maxon comic pattern gradational screen tone

Which screen tones were used?
Figure A: ① & ②
Figure B: ①, ② & ③

Figure B was made by layering and etching patches of screen tone.

Figure A

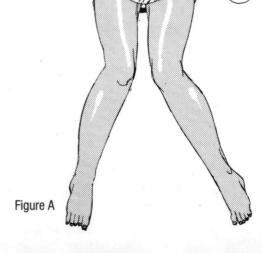

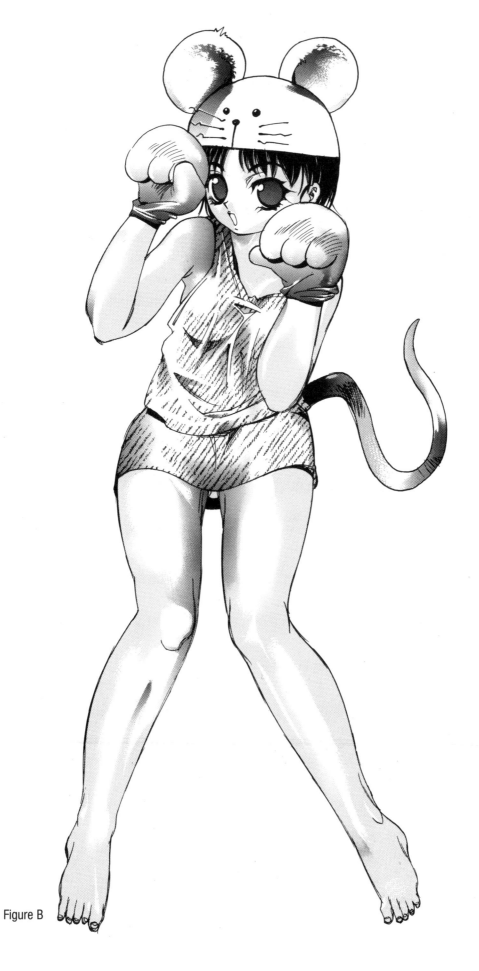

Figure B

Table of Contents

Tones add that "something special" to your characters4

Chapter 1: The Basics7

Types of Tones...8

Choosing Tools ...10

Selecting a Craft Knife Suited to Tone Work10

Craft Knives Recommended by Professional Artists.......................................11

White Ink ...15

Basic Screen Tone Techniques......................17

Basic Tone Work Process18

1. Etching Techniques20

 Holding the Craft Knife21

 Precision Etching ..22

 Vigorous Strokes—Creating Rough Etches......25

 Vigorous Strokes—Creating Sharp Etches.......26

 a. Cleaning Up Etched Areas29

 b. Aligning Tones...30

 c. Avoiding Outline Etching............................32

2. Choosing the Right Combination of Tones33

 Tone Value vs. Natural Color.........................35

 Color Scales...35

 Basic Tone Values36

 Shade and Shadow Tone Values....................38

3. Learning Screen Tone Techniques40

 Attaching and Cutting....................................40

 Using Layered Screen Tone Effectively41

 Layered Screen Tones42

 Single-Layered Tones and Perfect Overlap46

 Determining Tone Placement.........................48

 Detailed Tone Work, Using Photocopies49

Chapter 2: The Next Dimension51

Etching Based on Form....................................52

Filter Effects 1: Hexagonal Pattern54

Filter Effects 2: Overlapping Contours55

Simple Filters—Various Effects56

Facial Features of Female Characters60

Female Characters—Rendering the Face..........64

Female Characters—Rendering Parts of the Body...66

Light, Shadow, and the Female Form70

Depicting Shadows on the Female Body77

Simulating Leather 1: Gradation Using a Single Tone82

Simulating Leather Using a Single Gradational Tone....................................84

Simulating Leather 2: Gradation Using Layered Tones.........................88

Simulating Leather Using Layered Gradational Tones ...89

Placing and Etching Tones for Clothing............90

Step-by-Step Tone Work..................................94

Shower Scene ...95

Chapter 3: Character-Enhancing Backgrounds99

Water Spray...100

Cherry Blossoms ...100

Halos & Sunbeams...101

Clouds ...102

Creating Dramatic Clouds105

Special Effects ...108

 1. Lightning..108

 2. Light ...110

 3. Smoke ...112

Key Points in Smoke Tone Work.......................114

Backgrounds to Enhance the Characters.........118

Chapter 4: Putting on The Finishing Touch125

Girl in Wedding Gown......................................126

Girl with Wings ..129

Girl Posing in a Garden132

Final Words of Advice......................................135

Chapter 1
The Basics

In this chapter I introduce the fundamentals of tone work, from selecting tones and tools to the methods of etching and using tones to represent color in black-and-white illustrations. Screen tones play a role as important to manga as an operating system is to a computer. Keeping that in mind, if you read this book carefully—without skipping even the tiniest detail—I guarantee you will improve your artwork.

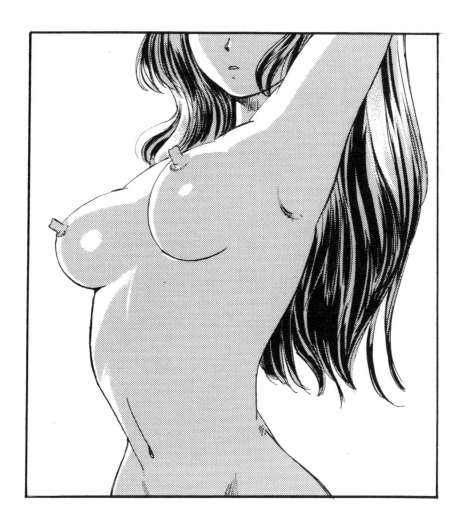

Types of Tones

Screen tones are an indispensable part of manga artwork. There are tones with tiny dots organized in rows or randomly scattered; gradational tones; tones that look like clouds; background and pattern tones; and many, many others.

A #61 tone is one with 60 rows of dots per square inch with a tone-density value of 10%. (Screen tone numbers in this book are based on those used by IC Inc., one of Japan's leadiing tone manufacturers.)

> IC S-61 is the most common of all tones.

1 square inch (25.4 mm)

A single row of 60 dots

#61 tone ==== Density of 10%

IC S-61

Manufacturers market their screen tone products under various names:
I-C Screen Youth
Deleter Screen
Comic-Screentone
Design Tone
Maxon Comic Pattern
J-Tone
Triart Comic-Sheet
Sam Comic Symbols

All of the tones and products discussed in this book can be ordered directly from the book's official website at http://www.supertonetechniques.com

Letraset's Screentones are marketed in Japan by AIM Inc.

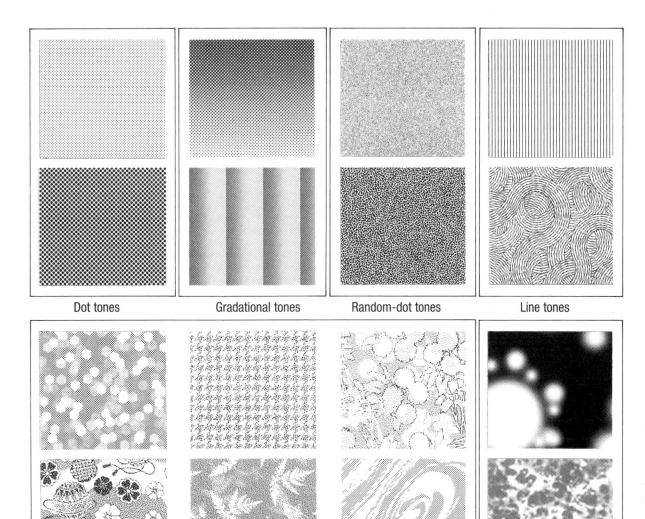

Dot tones

Gradational tones

Random-dot tones

Line tones

Pattern tones

Digital screen tones
(computer generated)

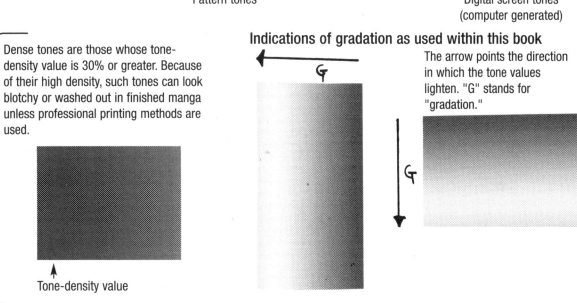

Dense tones are those whose tone-density value is 30% or greater. Because of their high density, such tones can look blotchy or washed out in finished manga unless professional printing methods are used.

Tone-density value

Indications of gradation as used within this book

G

The arrow points the direction in which the tone values lighten. "G" stands for "gradation."

G

Choosing Tools

Good tools are at the core of tone work, and of these, the craft knife is the one that has the greatest impact on the quality of an artist's final product, so be very discriminating when selecting your knife.

Selecting a Craft Knife Suited to Tone Work

① It should be light.

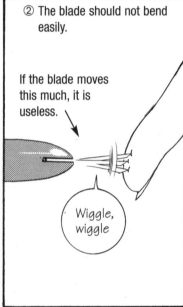

② The blade should not bend easily.

If the blade moves this much, it is useless.

Wiggle, wiggle

③ It should be easy to manipulate.

Craft Knives Used by the Author

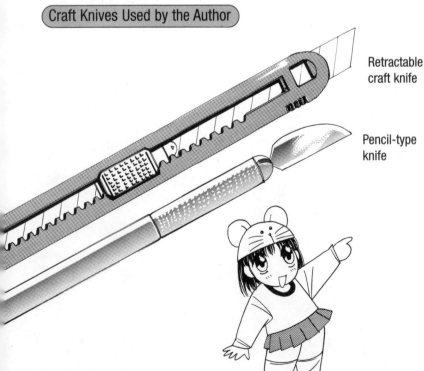

Retractable craft knife

Pencil-type knife

Check out the next page for an expert ranking of craft knives.

Craft Knives Recommended by Professional Artists

1st Place: NT Cutter A-551P
This knife is the easiest to use. Blades can be stored inside the knife, but this is not recommended as it will make the knife too heavy and unwieldy for tone work.

2nd Place: PLUS Cutter-S
Very easy to use, but the blade opening is not very secure, which can cause the blade to wiggle. Inserting small pieces of paper into the opening can minimize this.

3rd Place: NT Cutter D-400GP
Despite the limited types of surface etching that can be done with this knife, it is the best cutting.

4th Place: Too Silver knife

This knife also comes with a curved, crescent blade, which allows for a wider variety of etching. The standard straight blade is optimal for cutting.

5th Place: NT Cutter PRO A-1P
Despite being somewhat unwieldy, this is a popular knife.

Retractable Craft Knife

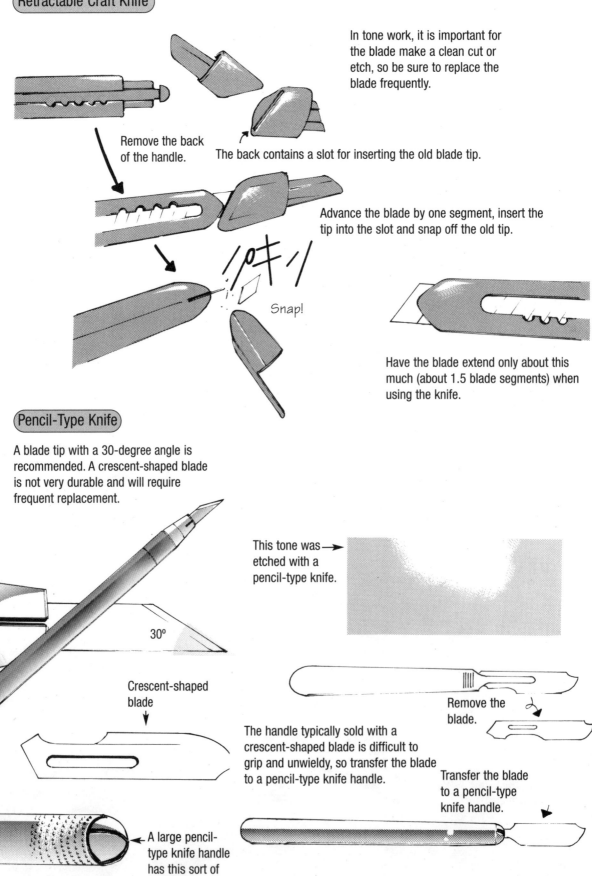

In tone work, it is important for the blade make a clean cut or etch, so be sure to replace the blade frequently.

Remove the back of the handle.

The back contains a slot for inserting the old blade tip.

Advance the blade by one segment, insert the tip into the slot and snap off the old tip.

Snap!

Have the blade extend only about this much (about 1.5 blade segments) when using the knife.

Pencil-Type Knife

A blade tip with a 30-degree angle is recommended. A crescent-shaped blade is not very durable and will require frequent replacement.

30°

This tone was etched with a pencil-type knife.

Crescent-shaped blade

The handle typically sold with a crescent-shaped blade is difficult to grip and unwieldy, so transfer the blade to a pencil-type knife handle.

Remove the blade.

Transfer the blade to a pencil-type knife handle.

A large pencil-type knife handle has this sort of opening for the blade.

Cutting and Etching

The pencil-type knife is superb for cutting. However, it is only capable of creating a bokashi (blurring) effect in terms of etching. The retractable knife, on the other hand, is capable of both etching as well as cutting. (Note that a pencil-type knife crescent blade is great for both etching and cutting.)

A #62 screen tone was used in this drawing.

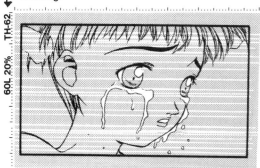

Aluminum Straightedge

A straightedge ruler has a number of uses in tone work, including tone flashes (discussed later in this chapter), lettering and backgrounds. In the example to the left, a straightedge was used to etch lines on a #62 screen tone, creating the effect of a lined screen tone.

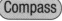

Using an aluminum straightedge prevents damage when the knife comes into contact with the ruler.

Compass

Being able to use a compass works in your advantage. Art supply shops normally carry compasses that will hold objects larger than a pencil, such as pencil-type knives.

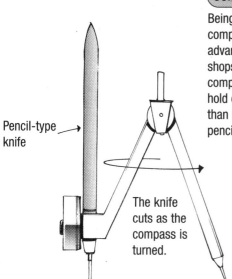

Pencil-type knife →

The knife cuts as the compass is turned.

Using a compass equipped with a knife can create interesting tone patterns such as this.

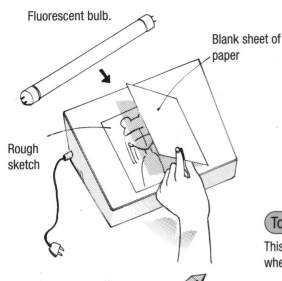

Fluorescent bulb.

Blank sheet of paper

Rough sketch

Light Tables

Lght tables use fluorescent bulbs to make drawings transluscent. The artist places a blank sheet of paper on top of a rough sketch to trace the drawing and produce a clean copy. The larger the light table, the easier it is to use.

Tone Scrubber

This tool keeps screen tones from buckling when they are rubbed.

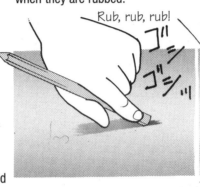

Rub, rub, rub!

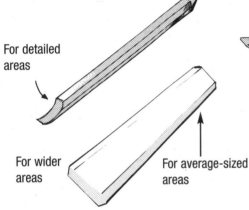

For detailed areas

For wider areas

For average-sized areas

The bottoms of bottles and other objects with blunt surfaces are not acceptable substitutes for an authentic tone scrubber.

Why these are not acceptable substitutes:
- They are large and cumbersome.
- They leave grooves and dents in the paper and the surface of the light table itself, making the lines of the drawing look distorted.
- They cause the tone to affix too strongly to the paper and surface of the light table.
- They are unnecessarily noisy.

Brush

Select a small, lightweight feather brush to sweep away excess screen tone and eraser bits.

Residue and tone scraps are extremely damaging to tone work. Clean the work area frequently.

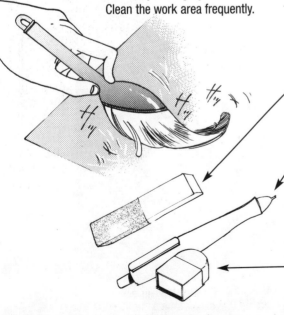

Sand Eraser

This kind of eraser functions similarly to a craft knife and is used to thin out screen tones. Select a soft one for this type of work.

Non-Photo Blue Pencil

Light markings made with blue lead disappear during the printing process. Consequently, this tool is indispensable for drawing cutting lines or tone value-separation lines. These non-photo mechanical pencils also come in sky blue. Hard leads are the easiest to use.

Eraser

This can be used to erase tone value-separation lines that have become too dark or to thin out screen tones with soft adhesive patterns.

White Ink

White ink is used to cover lines that were drawn and no longer needed as well as to correct lines drawn unsatisfactorily.

1 Standard white ink such as Dr. Ph. Martine's Pen-White is most commonly used.

Advantages It does not need to be diluted and it includes a dropper, making it easy to apply.

Disadvantages Although not a major problem, this type of ink does tend to rub off of screen tones.

2 Anime Color (Animex) White

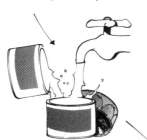

Be sure to thin out Animex with water.

Use an empty Animex jar.

Animex has a watery, gel-like consistency. Aim for a ratio of one part Animex to three parts water when diluting.

This type comes with a dropper dispenser.

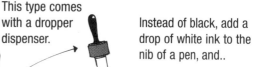

Instead of black, add a drop of white ink to the nib of a pen, and..

Draw away!

1 White Design Ink and Dr. Ph. Martin's Pen-White

Whoa!

Use the dropper dispenser to add the ink to a pen nib.

3 Misnon Correction Fluid

Use the brush attached to the lid to apply the correction fluid.

Dab, dab

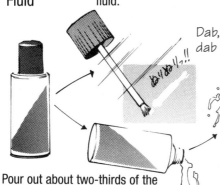

Pour out about two-thirds of the contents.

Fill the container back up with water to dilute.

Features of Animex and Mison Correction Fluid

Advantages Once applied to a screen tone, both are extremely difficult to remove.

Disadvantages The dilution process is laborious, and they dry too quickly.

In this example, a pen nib was used to apply white ink to the character's glasses.

Add to the nib of a pen and begin drawing.

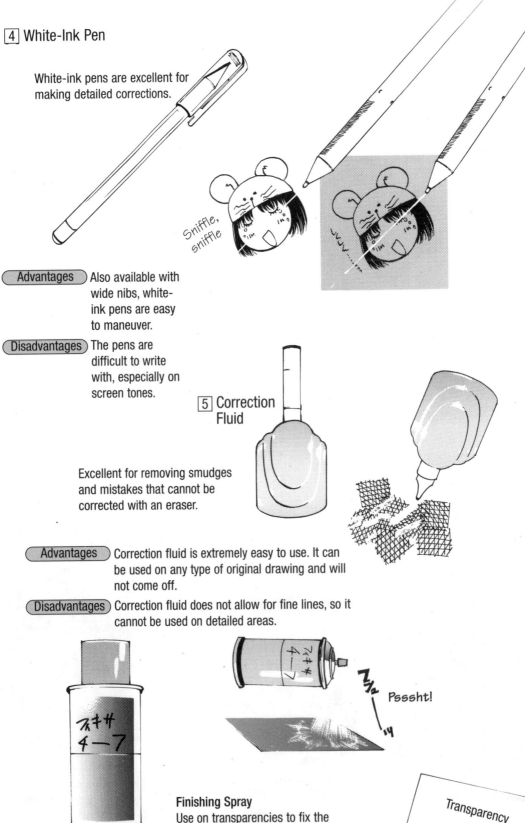

4 White-Ink Pen

White-ink pens are excellent for making detailed corrections.

Sniffle, sniffle

Advantages Also available with wide nibs, white-ink pens are easy to maneuver.

Disadvantages The pens are difficult to write with, especially on screen tones.

5 Correction Fluid

Excellent for removing smudges and mistakes that cannot be corrected with an eraser.

Advantages Correction fluid is extremely easy to use. It can be used on any type of original drawing and will not come off.

Disadvantages Correction fluid does not allow for fine lines, so it cannot be used on detailed areas.

Psssht!

Finishing Spray
Use on transparencies to fix the toner. Transparencies are colorless, transparent films used in a photocopier.

Transparency

Finishing Spray

Basic Screen Tone Techniques

This section features the fundamental skills artists must learn if they wish to master the advanced techniques presented later in this book. Combinations of the three rudimentary skills presented here allow for all sorts of intricate tone work.

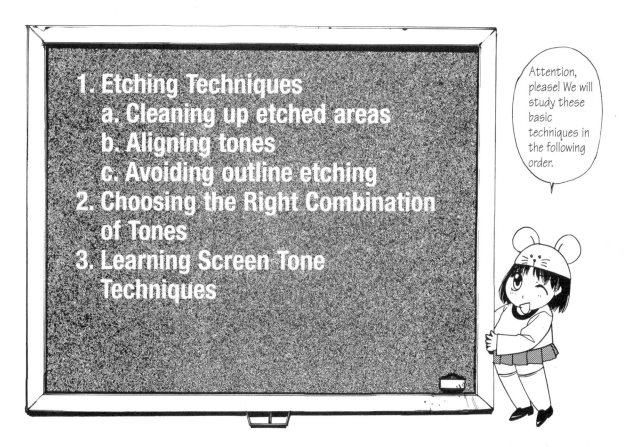

1. Etching Techniques
 a. Cleaning up etched areas
 b. Aligning tones
 c. Avoiding outline etching
2. Choosing the Right Combination of Tones
3. Learning Screen Tone Techniques

Attention, please! We will study these basic techniques in the following order.

What is written on these pages may seem rather obvious, but whether these techniques are put into practice makes a big difference in the final artwork. So, rather than sitting there saying, "Tell me something I do not know," pay close attention to what is written here and make sure you put these skills into practice.

In any circumstance or discipline, there are cases where paradox becomes fact, and in tone work, there are ways of dispensing with these basics. However, such cases are either extremely rare or are the work of individuals who do not have real respect for tones.

Basic Tone Work Process

This is a "genga," a drawing that represents the main poses.

OK, let's see how it's done.

First we attach the tone.

Next, make the tone overlap the area it will cover when finished.

See how I have it going over the lines?

Remember to make sure the tone overlaps the area it will cover.

See page 36 to learn how to affix tones.

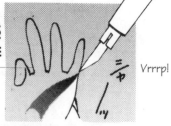

Vrrrp!

Cut along the lines you drew.

← Etch the background.

Etch, etch!

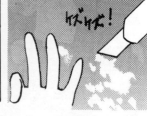

Cut the tone carefully.

Next comes the etching.

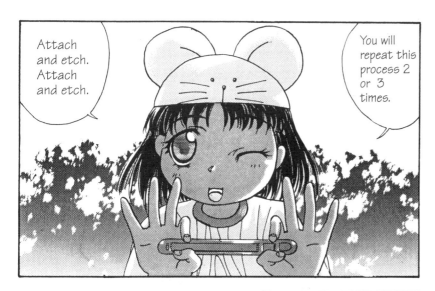

See Chapter 3 for creating sunlight effects such as rays shining through trees.

First attach tones to the hat, then work your way down to the face, the clothing and the other areas of the drawing.

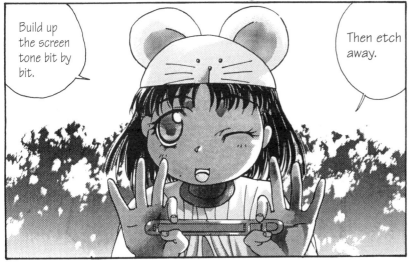

1. Etching Techniques

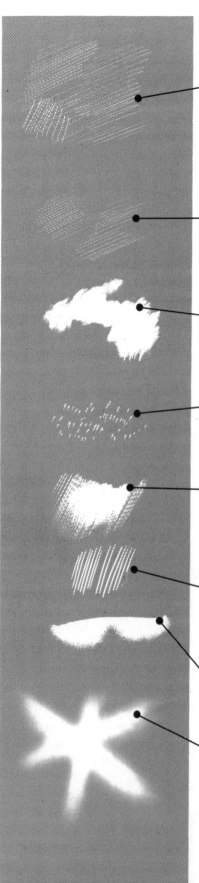

Double-Stroke Etching

Etching tones in a scribbling motion produces this effect. It is not the most popular technique, but produces nice effects when used sparingly. Think of it as a secret weapon when working with single-layered tones. Mastering this technique is definitely the mark of a skilled artist.

Single-Stroke Etching

Also known as "hatching," single-stroke etching involves a series of quick, straight strokes running in the same direction and is effective for creating rain or shower scenes.

Harakezuri (Patch Etching)

This technique is used to create a number of effects, including clouds and smoke. It can also create quite a mess, so don't forget to clean up the tone shavings after using this technique!

Hikkakikezuri (Tap Etching)

Use the tip of the knife to scratch the tone as though you were scratching it with your nail. An excellent secret weapon, this technique is often used to create water or flame effects.

Flash Etching

This is the most common etching technique. Flash effects are created by etching the tone with a series of quick strokes of the knife. This technique is used frequently for a number of other effects as well, including the sun and rays of sunlight.

Kakikezuri (Illustration Etching)

This is a standard technique used to give form to the drawing. The knife is held in the same way as to when using the flash technique, but the strokes are slow and deliberate.

Bokashi (Blur Etching)

This is another frequently used technique and appears in almost all types of tone work.

Sunakeshi (Eraser Etching)

Involving the use of either an abrasive or regular eraser to abrade the tone, this is yet another multipurpose technique. For best results, use flexible erasers. This technique is often used to suggest leather.

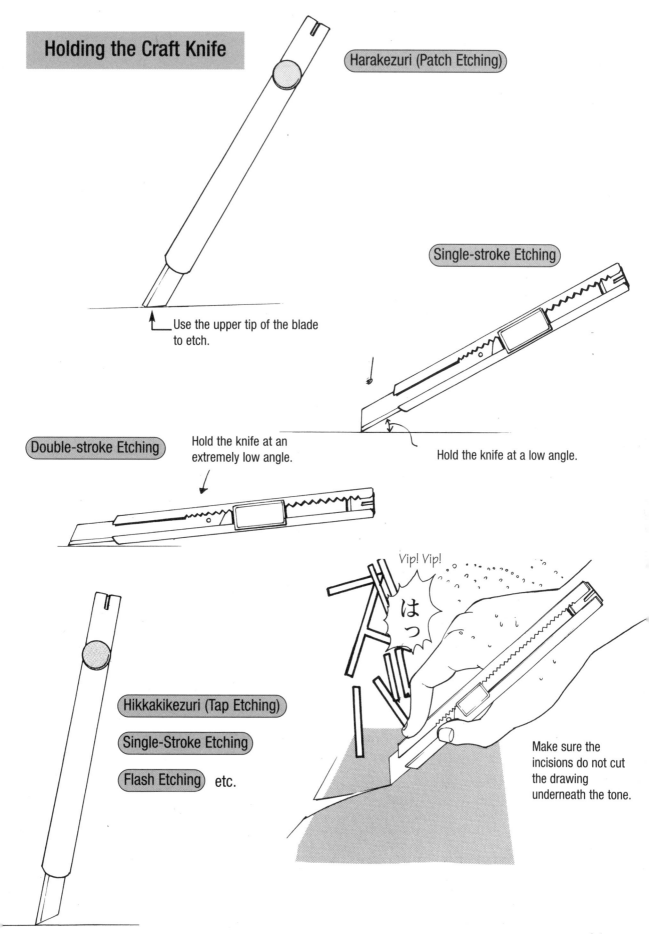

Holding the Craft Knife

Harakezuri (Patch Etching)

Use the upper tip of the blade to etch.

Single-stroke Etching

Hold the knife at a low angle.

Double-stroke Etching

Hold the knife at an extremely low angle.

Hikkakikezuri (Tap Etching)

Single-Stroke Etching

Flash Etching etc.

Vip! Vip!

はっ

Make sure the incisions do not cut the drawing underneath the tone.

Precision Etching

Pssst. I'm going to let you in on a secret!

The ability to etch with precision is vital to good tone work. But it is also very difficult to master, no matter how clearly it is explained. For example, I'll tell my new assistants something like, "Etch this at an angle just under 45 degrees," and they will answer, "I know, I know." Yet none of them ever get it right on the first attempt! The point I'm making is that while it is easy to grasp a concept mentally, it can be very difficult to get your hands to follow suit. Either the angle will be wrong or the etch will be sloppy. So, what should you do?

There are 3 key points.

Point 1: Keep the etch lines thin!

Point 2: Keep the etch lines straight!

Point 3: This may seem contradictory, but keep in mind only half of what I just told you. For the rest, try various angles on your own to discover what works best for you!

This etching is perfect.

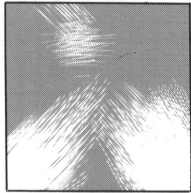

The etching above is sloppy. There is residual tone in the area to the left, where the etches should be solid and well-defined. The overall pattern is inconsistent and too wide.

If you etch carefully and get your tone to look like the example on the left, you are doing all right.

Beautiful!

That is just WAY too messy!

Point 1 Keep the etch lines thin!

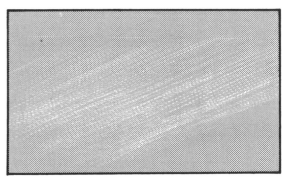

As you can see in this enlargement, the lines should be thin enough to divide the dots of a 60-line tone pattern into thirds (or, at the very most, in half).

This is how the example to the left looks in actual size. (IC 62 tone)

Point 2 Keep the etch lines straight!

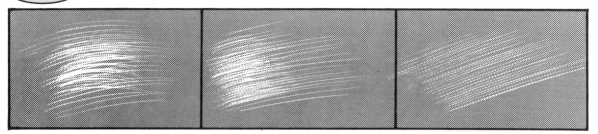

Too curved.　　　　　　　　Not bad.　　　　　　　　Just right.

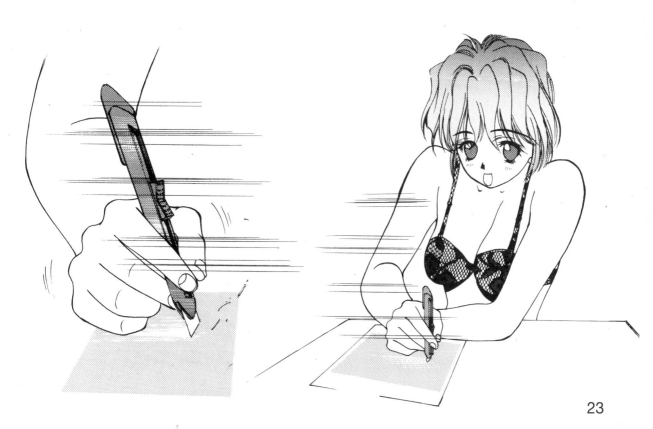

This may seem contradictory, but keep in mind only half of what I just told you. For the rest, try various angles on your own to discover what works best for you!

The flash-etching technique, which is what I used in the example below, lends itself best to explaining this point.

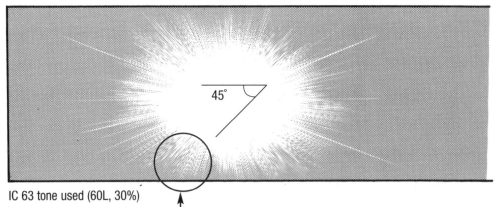

IC 63 tone used (60L, 30%)

A flash etch made at a 45-degree angle should look like this.

The screen tone should be etched right up to this position, which is where the other etches "intersect." (This patch should be totally white and free of tone. Anything less would appear sloppy.)

This is ever so slightly off the 45-degree angle.

The same holds true for all types of etching techniques. The precision of the etching pattern wll have a significant impact on the overall look of the final work, so please take time to practice these techniques. You don't necessarily have to make perfect radiating lines such as you see here. Experiment with different angles, but always keep the etch lines thin.

An etch at this angle does not fit the pattern.

45-degree flash etching

This is the most difficult angle to use with the flash technique. However, it is also the most effective for creating ultra-thin etches.

Use fast, thin strokes when etching the tone.

Thick lines will make the pattern look sloppy.

Basic Etching:
Etching at a
45-degree angle.

Vigorous Strokes – Creating Rough Etches

While it is important to etch the tone carefully, there are times when vigorous, rough strokes are desirable.

In examples such as the one here, rough strokes can be used to represent the texture of a skull or an old, gnarled tree.

Be careful not to over-etch when using rough tone techniques in small manga panels.

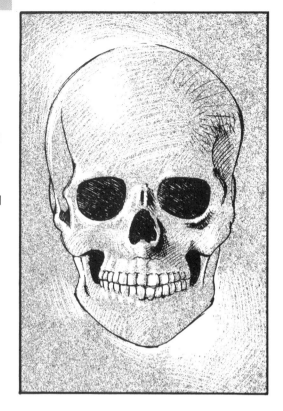

Yikes!

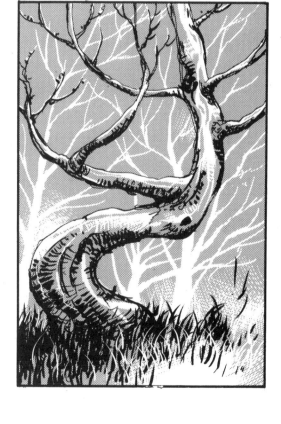

Vigorous Strokes – Creating Sharp Etches

Vigorous strokes are also useful for creating sharp etches to represent shards of glass or pointed, glittering objects.

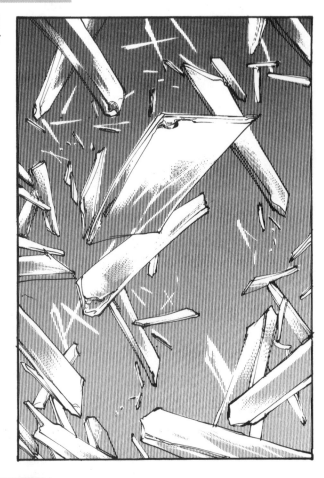

Etching Tips

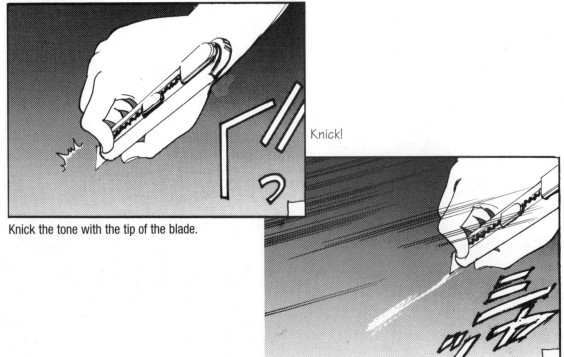

Knick the tone with the tip of the blade.

Pull back swiftly.

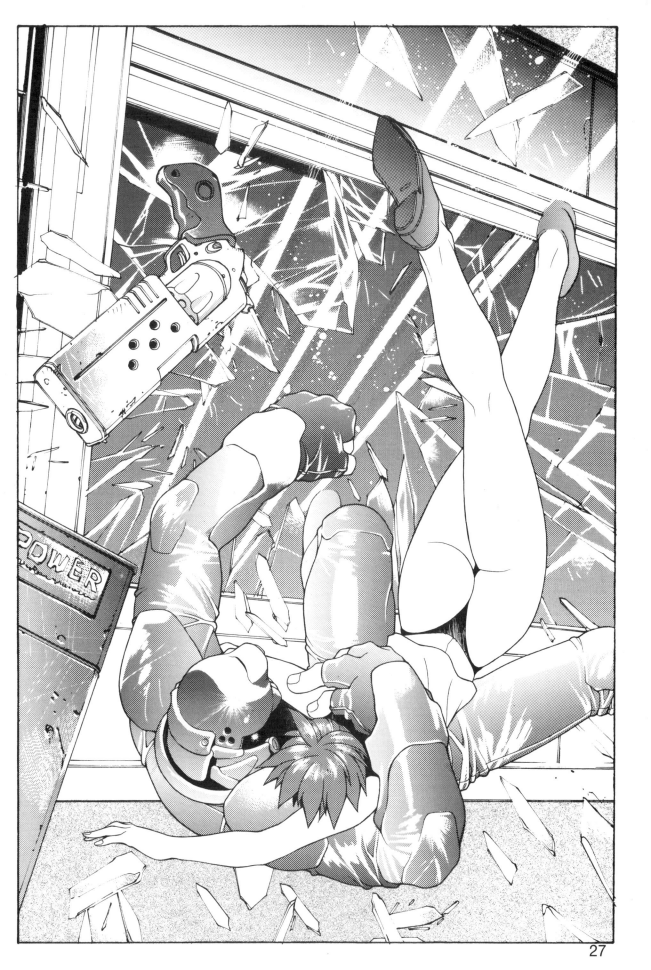

Place the original drawing in a position from which you can work comfortably.

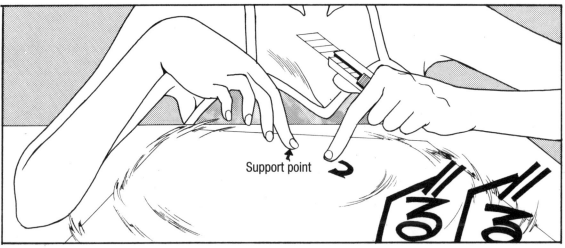

Support point

Spin! Spin!

Whether doing pen work or tone work, always place the illustration squarely on a desk or table if you expect to work efficiently..

Keep your eyes on the arrows!

The arrows indicate the direct in which the tone should be etched by right-handed artists. The opposite should hold true for left-handed individuals.

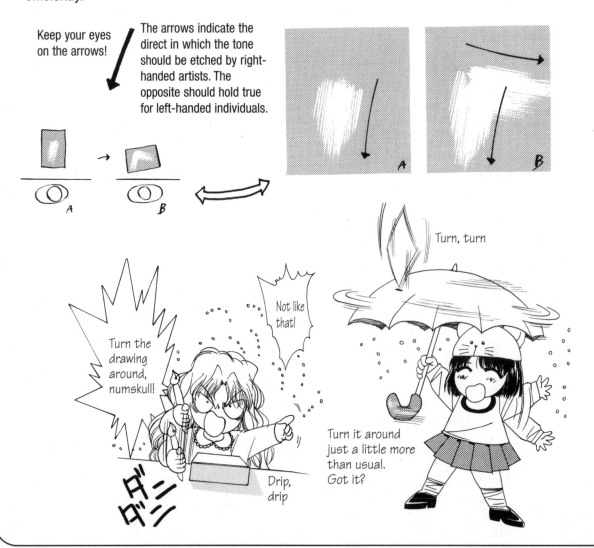

A

B

A

B

Turn, turn

Turn the drawing around, numskull!

Not like that!

Drip, drip

Turn it around just a little more than usual. Got it?

a. Cleaning Up Etched Areas

Leaving tone residue on the original drawing will make it look messy. Take a look at Figures A and B. Figure B is clearly the better of the two.

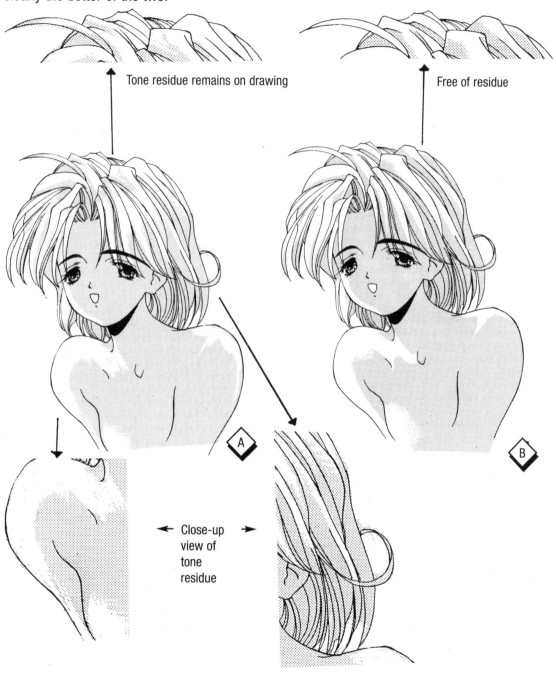

Tone residue remains on drawing

Free of residue

A

B

← Close-up → view of tone residue

b. Aligning Tones

The dots on a screen tone are usually printed at a 45-degree angle. Affixing the tone to the original so that the pattern continues at the same angle is referred to as "perfect alignment." The tone pattern should always run along this 45-degree angle.

Examples of perfectly aligned tones

Close-up of the illusration to the right.
As you can see, this tone is perfectly aligned at a 45-degree angle.

When using a photograph as the basis for an illustration, it is very important for the tone echings and pen lines to align properly. If they do not, the resulting image wil look nothing like the original photo.

Model: Mai Akiyama

Close-up

Screen tone version

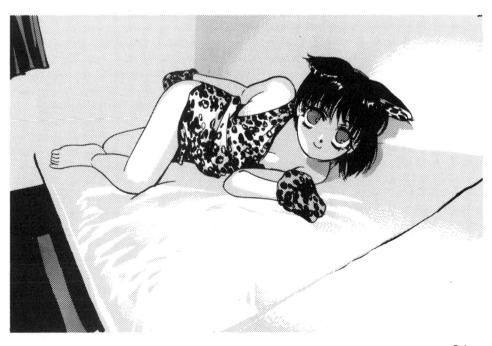

c. Avoiding Outline Etching

Avoid etching tones in a way that your etches merely follow the countor lines of the illustration. This is known as "outline etching," and will make your work look amateurish. Pay close attention to the folds and wrinkles in clothing, the unique angles of mechanical objects and other countour lines that lend themselves to outline etching.

Good

Examples of outline etching

Bad

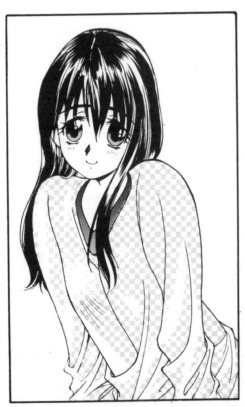

Good

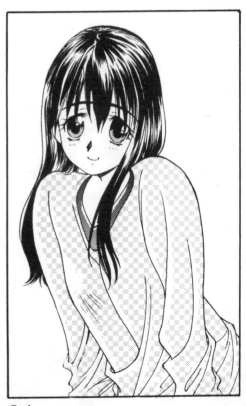

Bad

2. Choosing the Right Combination of Tones

Tones are used to represent color, texture and brightness in black-and-white illustrations. However, tones themselves are black-and-white or shades of gray. That means you must select the proper combination of tones to achieve the desired effects.

White ⟵⟶ Black

Key points

① Ensure the tone values are balanced
② Use a variety of tone values.

> Ensuring That Tone Values Are Balanced

Let's rearrange the four tone values at left to give them balance.

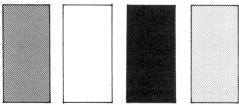

This arrangement has balance.

This one does not.

Does this clear things up? The tones are best arranged according to where the largest value contrasts lie. Focus on creating such contrast when working with tones.

The tone values in this illustration follow the order of 64, white, 61, white and 62, respectively, creating a comfortable balance.

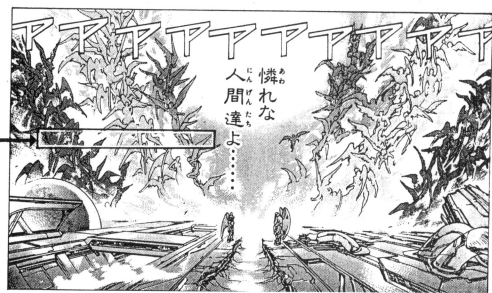

From "Bastard!! Dark God of Destruction" © Kazushi Hagiwara, Shueisha Inc.

Let's see if these four values can be
broken down even further.

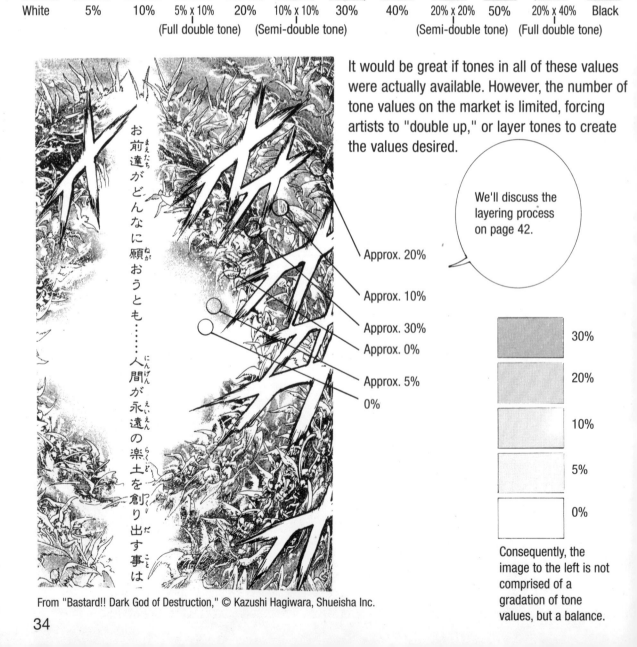

| White | 10% | 30% | Black |

| White | 5% | 10% | 5% x 10%
(Full double tone) | 20% | 10% x 10%
(Semi-double tone) | 30% | 40% | 20% x 20%
(Semi-double tone) | 50% | 20% x 40%
(Full double tone) | Black |

It would be great if tones in all of these values
were actually available. However, the number of
tone values on the market is limited, forcing
artists to "double up," or layer tones to create
the values desired.

We'll discuss the
layering process
on page 42.

お前達がどんなに願おうとも‥‥‥人間が永遠の楽土を創り出す事は

Approx. 20%

Approx. 10%

Approx. 30%

Approx. 0%

Approx. 5%

0%

| 30% |
| 20% |
| 10% |
| 5% |
| 0% |

Consequently, the
image to the left is not
comprised of a
gradation of tone
values, but a balance.

From "Bastard!! Dark God of Destruction," © Kazushi Hagiwara, Shueisha Inc.

34

Tone Value vs. Natural Color

Use #61 for yellow, #63 for green and a gradational tone for red to create the proper effects in the illustrations.

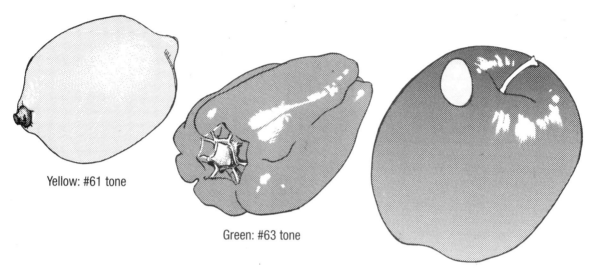

Yellow: #61 tone

Green: #63 tone

Red: Gradational screen tone

I get it! So, in manga, colors values have numbers, not names.

Hmmm

Color Scales

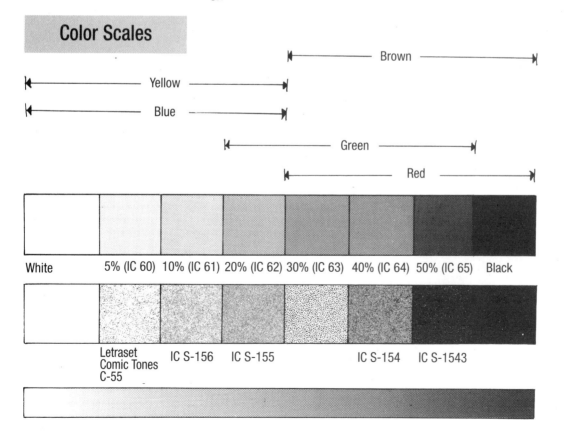

Brown

Yellow

Blue

Green

Red

| White | 5% (IC 60) | 10% (IC 61) | 20% (IC 62) | 30% (IC 63) | 40% (IC 64) | 50% (IC 65) | Black |

| Letraset Comic Tones C-55 | IC S-156 | IC S-155 | | IC S-154 | IC S-1543 |

35

Basic Tone Values

An illustration that is in the "basic stage" of tone work has its assorted "natural color" tones in place.

It is rare for a manga artist to decide which basic tones values to use before actually beginning the tone work. Such decisions are usually made after the first tones have already been placed on the drawing.

In Figure A, where a dark tone has been used to color the skin, a decision was made to make the character's shirt white. This achieves a nice balance and gives the skin a suntanned look. The eyes of the character in Figure A are also darker and therefore maintain a better contrast with the skin than those of the characters in Figures B and C.

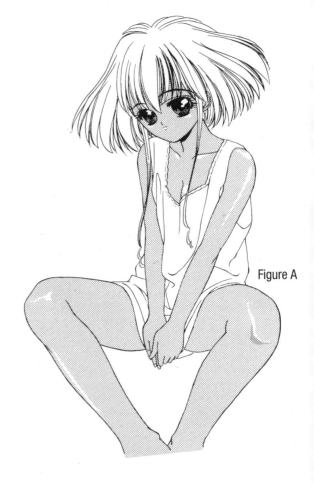

Figure A

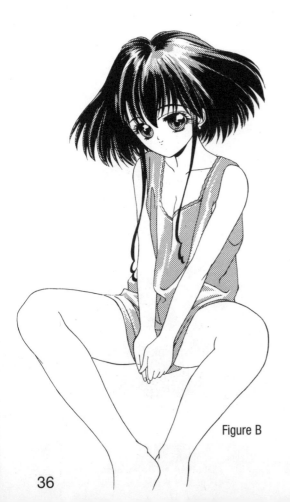

Figure B

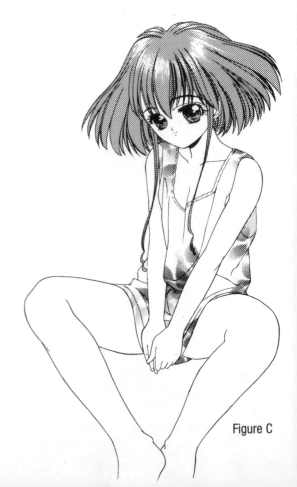

Figure C

A drawing will look well-balanced if the tone values used for the hair, clothing, skin, eyes and other features are repeated elsewhere in the image.

Tone Value Balance in the Jacketed Girl

D: The value of the jacket is echoed in her eyes.

E: The value of her hair is echoed in the skirt and ribbon.

F: The value of the ribbon is echoed in her eyes and skirt.

• Of these three examples, Figure F is the most successfully balanced.

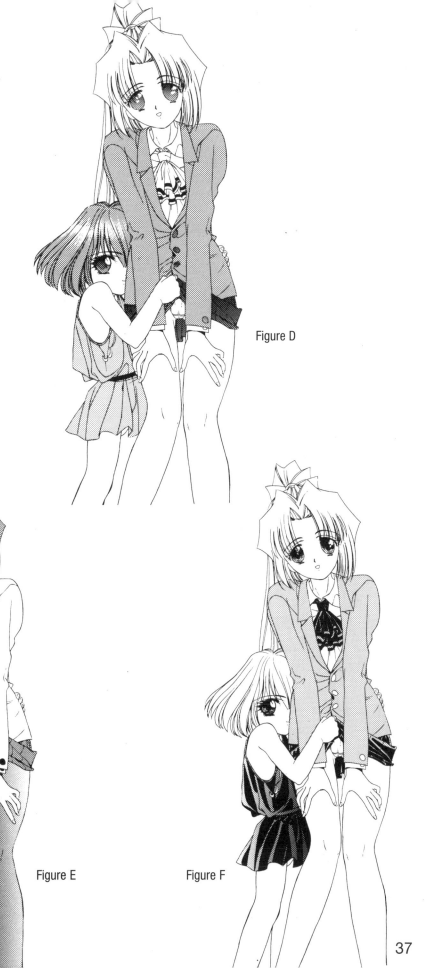

Figure D

Figure E

Figure F

Shade and Shadow Tone Values

Using a tone value that is darker than the tone value of the object creating the shadow (as in Figure B) is more effective than using tones of the same value for both the shadow and its source (as in Figure A).

Shading (#61 tone)

Shadow [Figure cast in shade] (gradational tone)

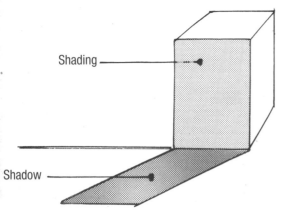

Shading

Shadow

The illustration above shows the effective use of these shadow and shading concepts. A #61 tone was used for the shading on her face, while a darker value gradational tone was used for the shadow created on her shoulder by the jaw. The graduated use of shading produces a natural effect of the play of light and shadow.

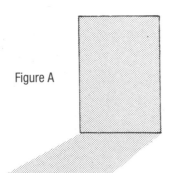

Figure A

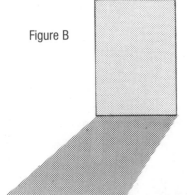

Figure B

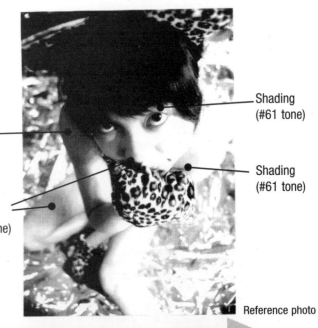

Shading (#61 tone)

Shading (#61 tone)

Shading (#61 tone)

Shadow (#61 tone and gradational tone)

Reference photo

In the illustration on the opposite page, semi-doubled gradational tone was used in some sections to give greater definition to the shadowed areas.

3. Learning Screen Tone Techniques

Attaching and Cutting

① Affix the screen tone so that it overlaps the outer edges of the illustration. This will prevent dust and particles from getting underneath the screen tone and allow for a cleaner final piece.

② Next, draw the value-separation lines with a non-photo blue pencil. If you want, you can draw these lines using a non-photo blue pencil before attaching the tone. Be sue that the lines are drawn lightly, though, to prevent them from showing up in printed copies of your manga.

Value-separation lines are also used in animation, where they define areas of light and shadow.

③ Using a drawing motion, cut the screen tone along the value-separation lines Because the lines themselves have a width, try to cut directly on top of the lines, not within them.

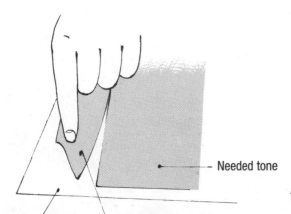

The drawn lines themselves have a width.

— Needed tone

Drawing This section of tone will be removed.

④ Remove unneeded sections of tone.

⑤ Finally, etch the tones that remain on the drawing.

Make sure you understand the shape of the object in your illustration before drawing value-separation lines. For example, in this illustration, value-separation lines were drawn to define the areas where shadow tones would be used. The shadow underneath the brow of the skull gives proper definition to the eye socket. However, the shadows along the cheekbone and jawbone look out of place.

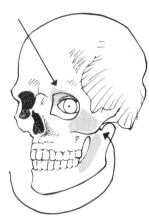

Using Layered Screen Tone Effectively

Layered tones can be twice as effective as single layers of tones.

Double up the screen tone and you'll make me sexier than ever...

That's why you have to learn how to layer tones!

41

Layered Screen Tones

Place the smaller tone on top.

Layer Order
Always place the smaller tone on top of the larger tone. Some say that placing the smaller piece underneath the larger tone keeps the smaller one from coming off, but it will also make your tone work more difficult.

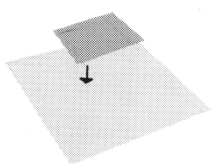

(3 Methods of Layering) These three methods are essential for creating different gradations of tone value.

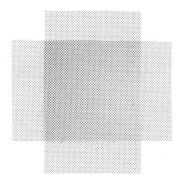

Perfect overlap

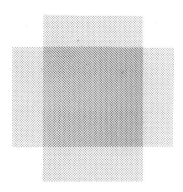

Semi-double

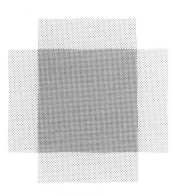

Full double

— Close-up —

Perfect overlap
The dots on both pieces of tone overlap perfectly.

Produces the lightest value

Semi-double
The dots on the upper tone are slightly off-center of those on the tone underneath.

Produces a medium value

Full double
Both the dots on the upper and lower tones are fully exposed.

Produces the darkest value

Manipulating Densities of Layered Tones

Please note that a perfect overlap consisting of two 10% tones will have a tone density value of 12% to 15%. It is impossible for this combination of tones to create a value of 10%.

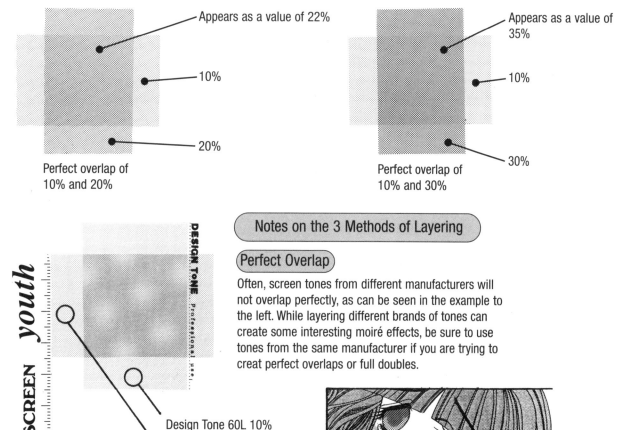

Appears as a value of 22%

10%

20%

Perfect overlap of
10% and 20%

Appears as a value of 35%

10%

30%

Perfect overlap of
10% and 30%

Notes on the 3 Methods of Layering

Perfect Overlap

Often, screen tones from different manufacturers will not overlap perfectly, as can be seen in the example to the left. While layering different brands of tones can create some interesting moiré effects, be sure to use tones from the same manufacturer if you are trying to creat perfect overlaps or full doubles.

Design Tone 60L 10%

I-C Screen Youth 60L 10%

Eyes: IC 62 (60L, 20%) Example of good full-double layering

Semi-Double

Try to prevent a line pattern from being created. It will not look good.

This looks like a tone with oblique lines, which isn't the desired effect.

Full Double

Avoid layering two tones whose values are both dark. Fully doubled tones with dense patterns tend to print badly if they are dark in value, and the dots, which are large, lose their shape.

Both tones used are #35. 42.5L, 50%

Layering-Compatible Letraset and IC Dot Screen Tones

Letraset	IC
1213-70s series	60s series
1212-60s series	50s series
1211-50s series	40s series
1210-40s series	30s series
1209-30s series	20s series
1208-20s series	10s series

A minor moiré effect can still occur in screen tones with 60 lines of dots, depending on the manufacturer.

The following assumes use of Designtone TH's 60-line dot tone and IC Youth Y-1231 to 1233 60-line dot tone:

① With Letraset 1213, no moiré is produced. Minor moiré is created with Letraset 70-series tone. Letraset II's 70-series tones also produce moiré.

② Deleter's gradational screen tones SSE413, 414 and 420 are classified as 65-line tones, but they are able to overlap perfectly with the standard 60-line tones listed above.

③ Deleter's digital screen tones and Designtone's digital tones both come in 60-line formats, but do, in fact, cause a minor moiré effect. Deleter's SE531, 577 and 632 will cause definite moiré, but they are the exception. Frequently, there are tones that appear to have 60 lines but will not overlap. Caution: The following tones are similar and, hence, easy to confuse:

- IC Youth digital screen tones Y1531, 1533 and 1592
- Deleter's gradational screen tones SSE436, 448 and 474
- Designtone's gradational screen tones TH476 and 756

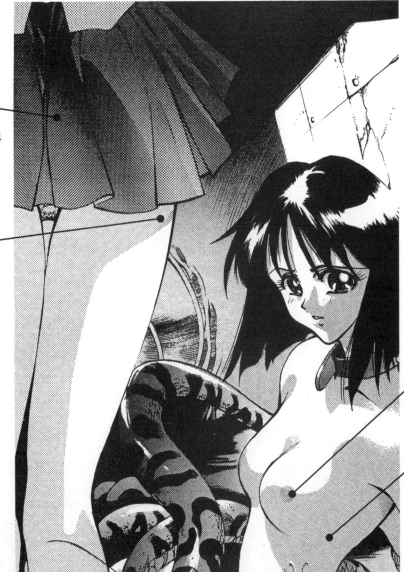

Skirt
(Semi-double)
Designtone TH407
and Deleter SSE414

Skin
(Perfect overlap)
Letraset 71 and
IC 61

Breasts
(Tone for
areolae in
perfect overlap)
IC 61 and
Letraset 71
(skin)

44

©Yoichi Kadoi

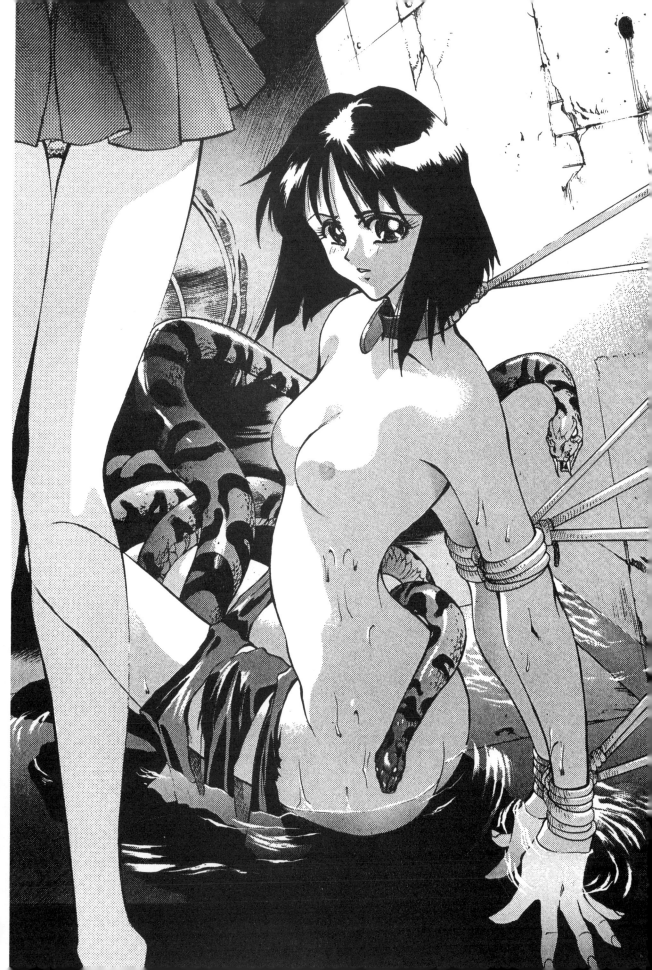

Single-Layered Tones and Perfect Overlap

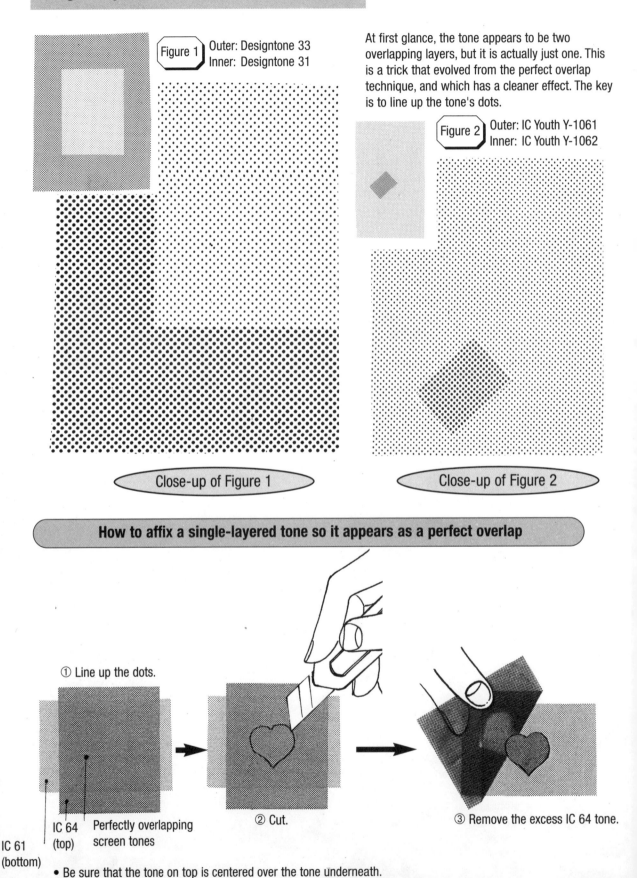

Figure 1
Outer: Designtone 33
Inner: Designtone 31

At first glance, the tone appears to be two overlapping layers, but it is actually just one. This is a trick that evolved from the perfect overlap technique, and which has a cleaner effect. The key is to line up the tone's dots.

Figure 2
Outer: IC Youth Y-1061
Inner: IC Youth Y-1062

Close-up of Figure 1

Close-up of Figure 2

How to affix a single-layered tone so it appears as a perfect overlap

① Line up the dots.

② Cut.

③ Remove the excess IC 64 tone.

IC 64 (top) Perfectly overlapping screen tones

IC 61 (bottom)

• Be sure that the tone on top is centered over the tone underneath.

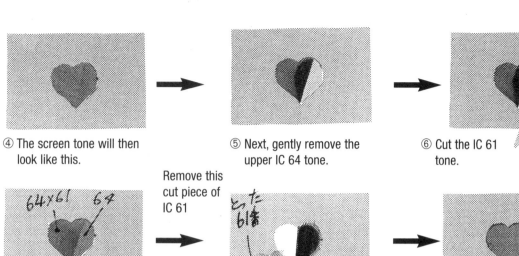

④ The screen tone will then look like this.

⑤ Next, gently remove the upper IC 64 tone.

⑥ Cut the IC 61 tone.

Remove the piece you just cut.

Remove this cut piece of IC 61

⑦ Return the IC 64 to its proper position.

⑧ Peel away the other side of the IC 64 and remove the remaining IC 61.

⑨ Return the IC 64 to its spot, and you're finished!

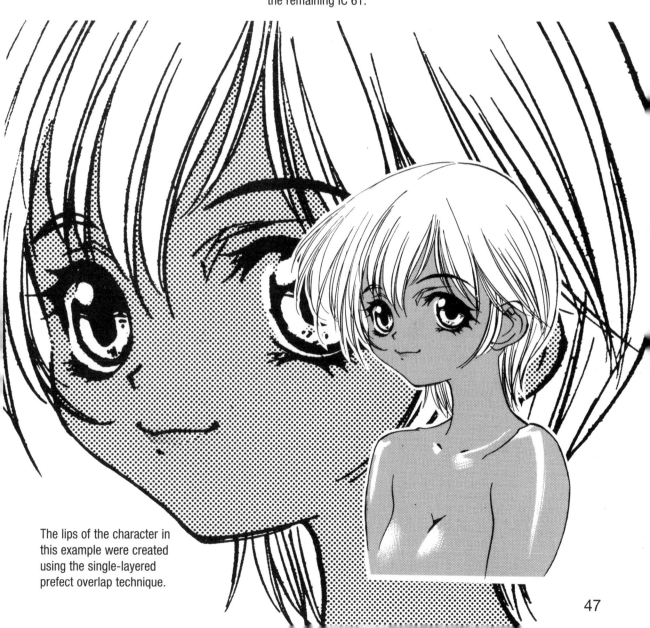

The lips of the character in this example were created using the single-layered prefect overlap technique.

Determining Tone Placement

Produce a unique, elegant work by using single-layered tone of a value similar to overlapped tones in areas where overlapped tones would normally be used, or by combining tones to create patterns.

Close, but no cigar!

An example of well-placed tones

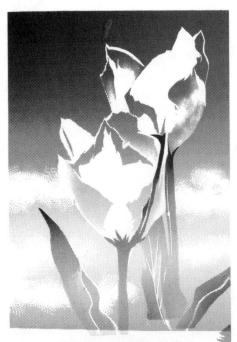

The same image, this time using just single-layered tone. (Refer to Chapter 2 for single-layered tone etching techniques.)

Detailed Tone Work

Detailed tone work refers to the combination of tiny pieces of tone. In the past, this practice was frowned upon because it was thought to produce shoddy-looking work. However, if you can manage to cut perfectly overlapped tone with precision, no one should notice that you've used this technique. Only attempt detailed tone work in small areas of your illustration, though

The key is to cut between the rows of dots.

Step-by-step instructions

① Get two identical sheets of tone.

② Match them so that the tones overlap perfectly.

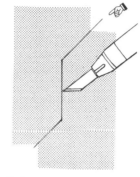

③ Cut between the rows of dots.

④ Remove the overlapping tone. Now there appears to be only a single sheet.

If the piece to be matched up is larger than 0.75 inch to 1 inch, then the work will lose its subtlety and finesse.

Awesome!

Using Photocopies

Adding photocopied images to your work is a fast and easy way to produce any number of drawings.

Whew! I really need to take a break.

So like, turn the page, OK?

49

Caution in Using Copies!

The toner (ink) used to create photocopies comes off easily, so be sure to use a fixative spray.

If you neglect to spray the photocopy with fixative and then remove screen tone from the photocopy, the toner will stick to the adhesive back of the screen tone and ruin the image.

Fixative is often used on charcoal and pastel drawings to prevent the loose charcoal or chalk particles from smudging or floating away.

Chapter 2
The Next Dimension

In this chapter, we will move beyond the basic skills taught in the first chapter and begin exploring more sophisticated tone techniques.

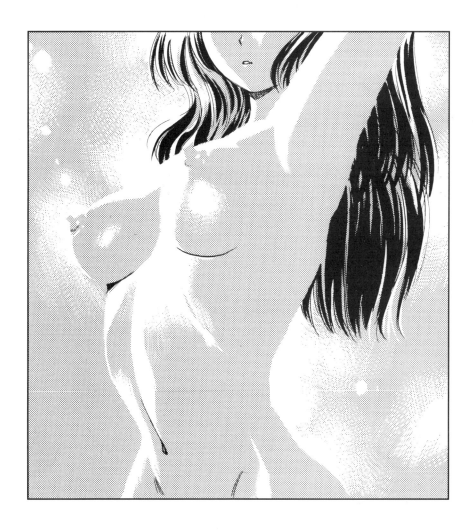

Etching Based on Form

Etching a subject's form—even when using just one sheet of tone—enables you to produce a refined graphic portrayal.

The illustration at the top of this page is a simple pencil sketch. Some areas of the artwork below the sketch feature layered tones, but only one sheet of tone was etched.

*Form means the shape of a subject and can be likened to a contour or silhouette.

Gasp! You don't really want to draw me so, like...detailed, do you?

Detailed Drawing

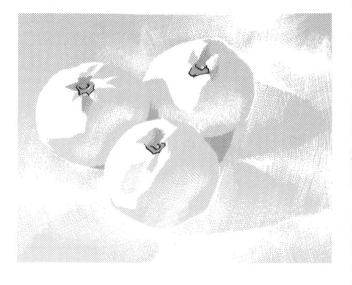

Who turned off the lights?

Drawing According to Form

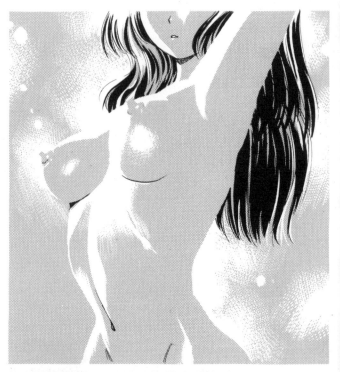

Even a beautiful woman can be illustrated using just one sheet of tone.

The complicated background in this photo can be rendered using only one sheet, and the final image will appear more elegant and uncluttered than an ink drawing.

To produce an elegant final work, use gradational screen tone.

Etch the background according to form. Trying to capture this detail in pen would produce a cluttered image.

①

This line was etched using an aluminum straightedge.

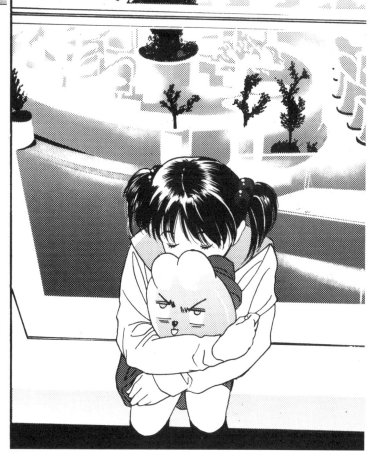

② Finished!

53

Filter Effects 1: Hexagonal Pattern

There are a number of specialty tones on the market that create this effect, but it's possible to create even better effects using ordinary tones.

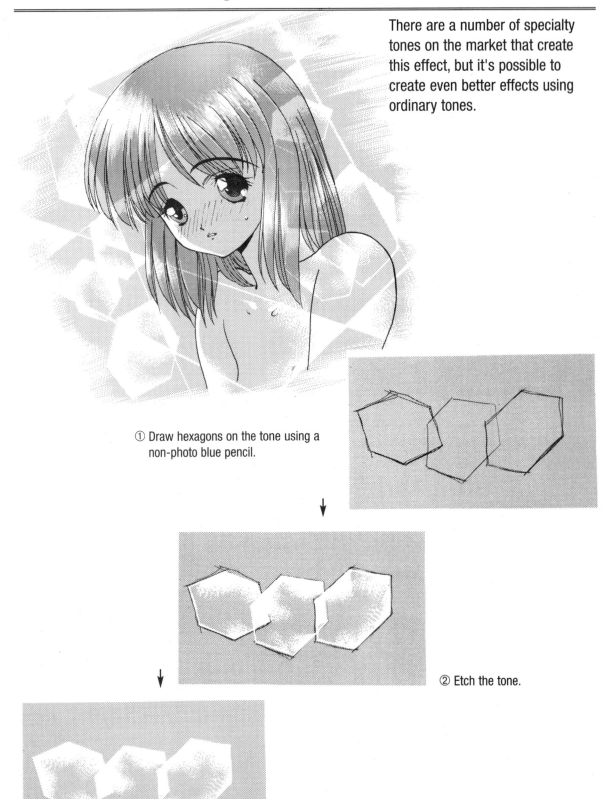

① Draw hexagons on the tone using a non-photo blue pencil.

② Etch the tone.

③ Erase the pencil marks, and voila!

Filter Effects 2: Overlapping Contours

This is one technique that creates the impression of blurred tone.

Bonus technique!

Create a subtle moiré effect to prevent the eyes from looking flat, and add white to the moiré areas with thinner values (perfectly overlapping areas).

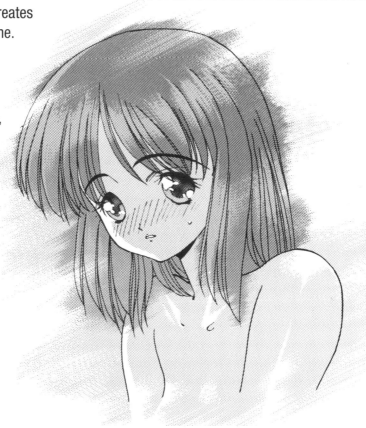

This is a technique for making etch strokes appear orderly without perfectly aligning the screen tones.

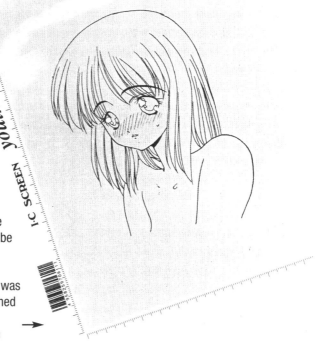

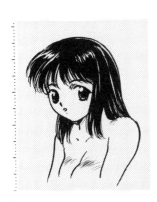

Normally, all of the tones used would be aligned perfectly straight. Here, however, the tone was purposefully attached at an angle to get clean-looking etch strokes.

Simple Filters—Various Effects

Rather than affixing the screen tone as you would normally, adding instead a few competent etches to a patterned screen tone can produce a filter effect. This effect does not require that you be conscious of maintaining a sense of depth—only that you pay attention to the composition's overall balance. It's a piece of cake once you get used to it.

A The only etching actually added were strokes like these. The key is to avoid etched lines extending to the character's face. The same etching techniques were used for both Figures A and B. The only difference is the type of tone used.

B

C

D Hexagonal pattern

The effects used in Figures C and D are also similar. The difference is that in D, shape was given to the etched areas.

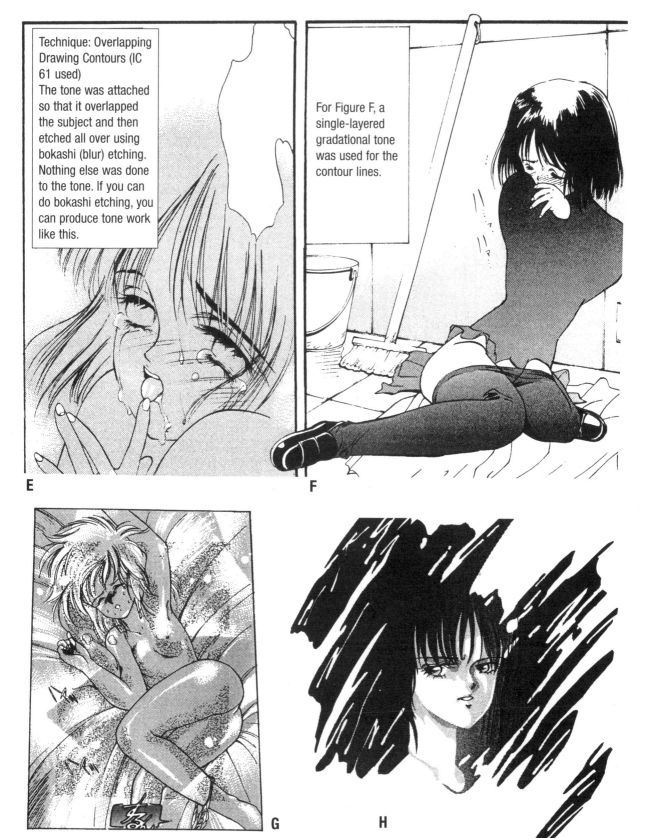

Technique: Overlapping Drawing Contours (IC 61 used)
The tone was attached so that it overlapped the subject and then etched all over using bokashi (blur) etching. Nothing else was done to the tone. If you can do bokashi etching, you can produce tone work like this.

E

For Figure F, a single-layered gradational tone was used for the contour lines.

F

This illustration was created by first etching out the bright areas and then adding a hexagonal pattern. Next, a random-dot tone was added, and again etched with a hexagonal pattern. The key was to etch out more than usual to avoid the composition from becoming overly dense, since both a #61 dot tone and random-dot tone, both with hexagonal etching, were used.

G

H

To create the effect seen above, the artist sketched the character's face and hair on the reverse side of the original drawing. The drawing was then flipped over and the tone cut to match the lines of the sketch on the reverse (made visible using a light table).

しょう
けだわ…
全さで
…

そらく

└┐I

For this, the sketch was flipped over and the hair drawn on the the reverse. The tone was then etched atop the original drawing, following the shape sketched on the backside (again using a light table). A special effect was created by adding thin strips of patterned tones to the top and bottom borders.

For Figures L, M, N and O, tones with different numbers of lines were used to suggest different textures in the hair, clothing, panties and the background. In a manner of speaking, the filter effect was used in these four panels as well. To achieve these textural contrasts, use tone groups with differences of 20 lines in density. (For example, from the 60s series, 40s series and 20s series, plus gradational tones; or from the 70s series, 50s series and 30s series, plus gradational tones.)

Letraset 31 and 33 were used for Figure O, unifying the composition with large dots. The white strokes are not etches but correction fluid used to achieve a Pop Art feel.

In the illustration to the right, oblique pen lines were added and then overlaid with #61 tone— quite the opposite of the oblique, white etch strokes used for Figure B.

J —

L —

M —

N —

O —

└K

The characters are unified through the use of a large-dot tone. A #61 tone was used for the background.

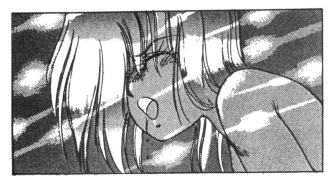

P A different feel was achieved here by adding white pulses to interrupt the long, oblique etches.

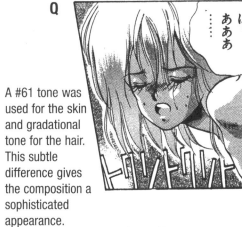

A #61 tone was used for the skin and gradational tone for the hair. This subtle difference gives the composition a sophisticated appearance.

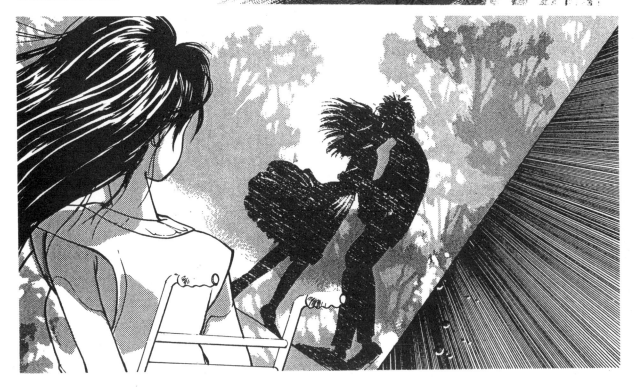

As with Figure E, etched strokes overlap drawn contours again here. The flash-etching techninque was used to achieve the effect.

S For the background, the trees were etched into #61 tone, and the full-double technique was used in the layered area. This worked extremely well, as the trees, while in the background, gave the image a soft-focus filtered effect.

Facial Features of Female Characters

The Eyes Rather than visualizing the iris and pupil as solid forms, conceptualize them instead in terms of design, and represent them using abstract forms.

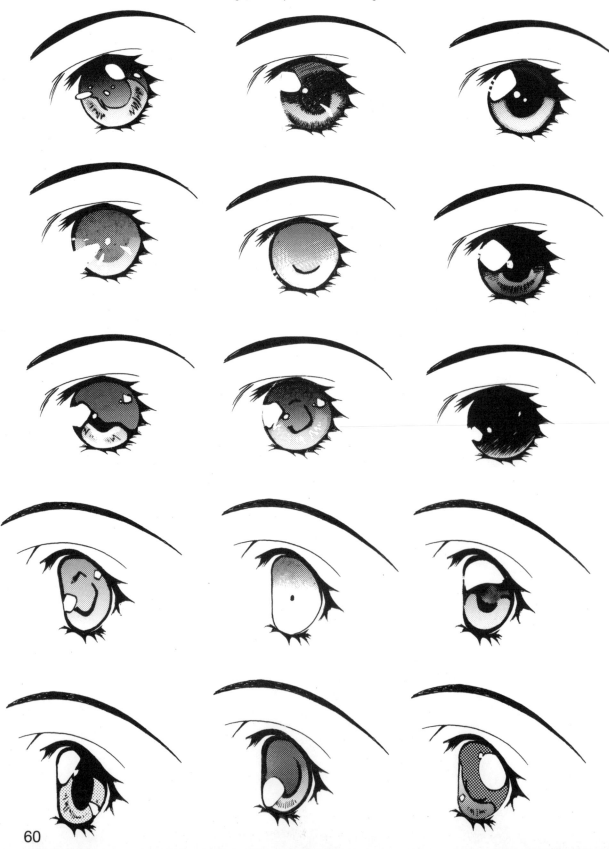

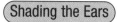

Shading the Ears

Use a key frame or large panel of your manga to establish the tone-work pattern you will use for the ears.

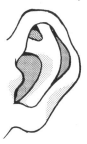 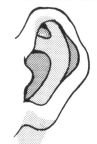 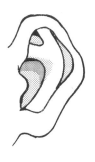

These are the most common and simplest ways of rendering the ears.

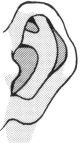 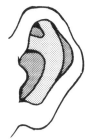

© Kotaro

Ears are often tiny, so any layering used for the outer ear will certainly result in moiré.

Avoid moiré!

Nose shading

Keep in mind the three-dimensional form of the nose when adding shadow. The way shadows fall across the nose indicates the direction of the light source.

Be careful not to make the nose's ridge overly large.

Side view

Light source Light source Light source Light source Light source

Shade under the nose

Shadow

Reflected light

Frontal view

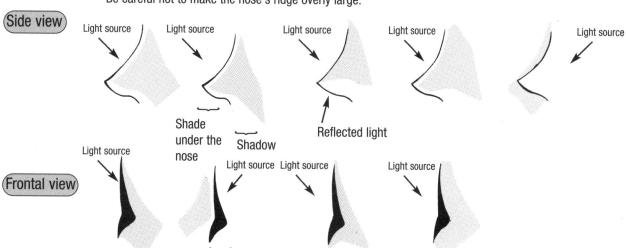

Light source

Light source Light source Light source

Solid black is often used from a design perspective.

61

Hair

Steps for Adding Highlights

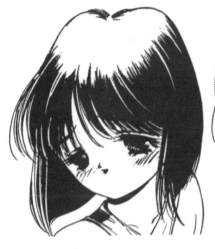

① Genga (original drawing)

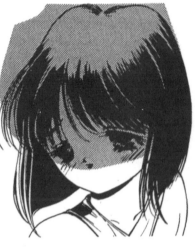

② Add tone (IC 63).

③ Draw value-separation lines on the screen tone.

④ Etch along the value-separation lines with a craft knife, then erase any remaining pencil marks.

⑤ Add a few single-stroke harakezuri (patch) etches.

⑥ Remove the excess tone covering her face and you're done.

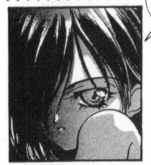

I'm your hair-etching model for this section.

Single-stroke etching

Blended etches shifting from hikkakikezuri (tap etching) to single-stroke etching.

Blended etches shifting from harakezuri (patch etching) to single-stroke etching.

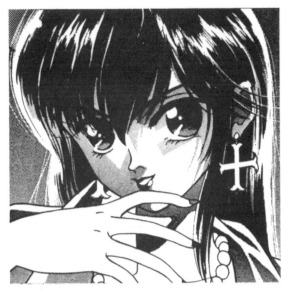
Single-stroke etching

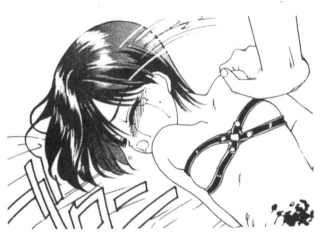
Harakezuri etching

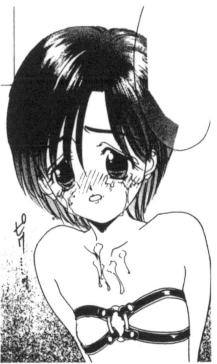
Shifting from hikkakikezuri
to single-stroke etching.

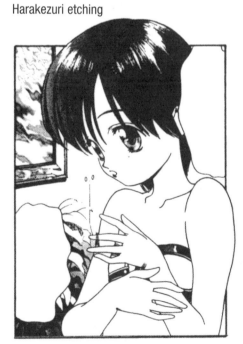
Shifting from hikkakikezuri
to single-stroke etching.

Single-stroke etching

Shifting from hikkakikezuri
to single-stroke etching.

Female Characters–Rendering the Face

The key to rendering the face is not the etching technique used, but the ability to achieve a three-dimensional feel.

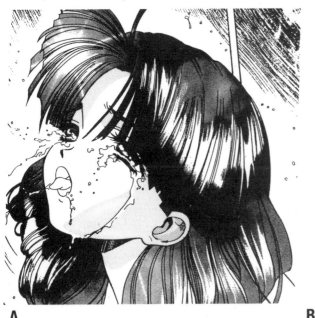

A

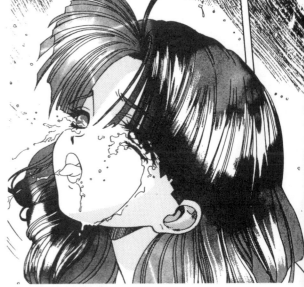

B

For Figures A and C, value-separation lines were used to define the hollow of the cheek, while they were used to define the cheek's swell in Figures B and D.
Of A and B, A is more suited to the character's heart-shaped face. Of C and D, D is more suited to the character's round face.

> If you are confused about what sort of contour to use, match the line to the shape of the character's face.

Contour line for hollow cheeks

Contour line for full cheeks

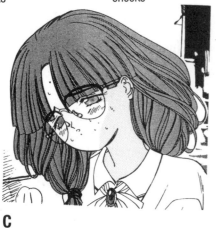

C

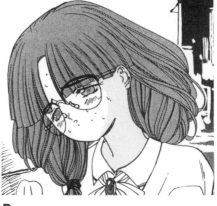

D

E

Here, tone was used rather than an inked line.

The use of tone instead of inked lines from the character's ear to jaw to show three-dimensionality produces an interesting effect.

あ…っ
はい!!

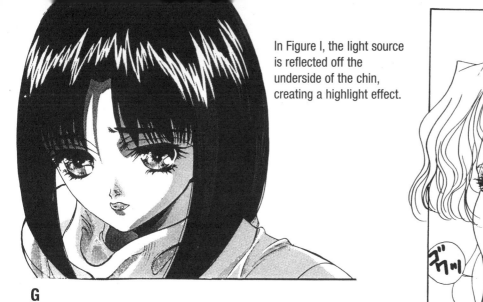

G

In Figure I, the light source is reflected off the underside of the chin, creating a highlight effect.

I

© Satoshi Matsuzawa

F

Tone follows the contour lines in figures F, G and H.

Subtle shadows were added underneath the eyebrows and on the noses of Figures J and K. This shading was used more for visual design than to bring depth to the drawing.

H

© Satoshi Matsuzawa

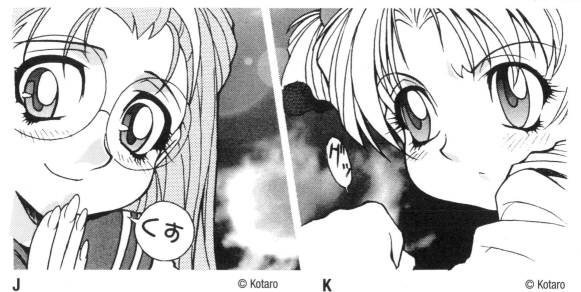

J　　　　　© Kotaro　　　**K**　　　　　© Kotaro

Female Characters—Rendering Parts of the Body

Hands

Although human fingers actually have three joints, drawng just two joints works better visually in manga and animation.

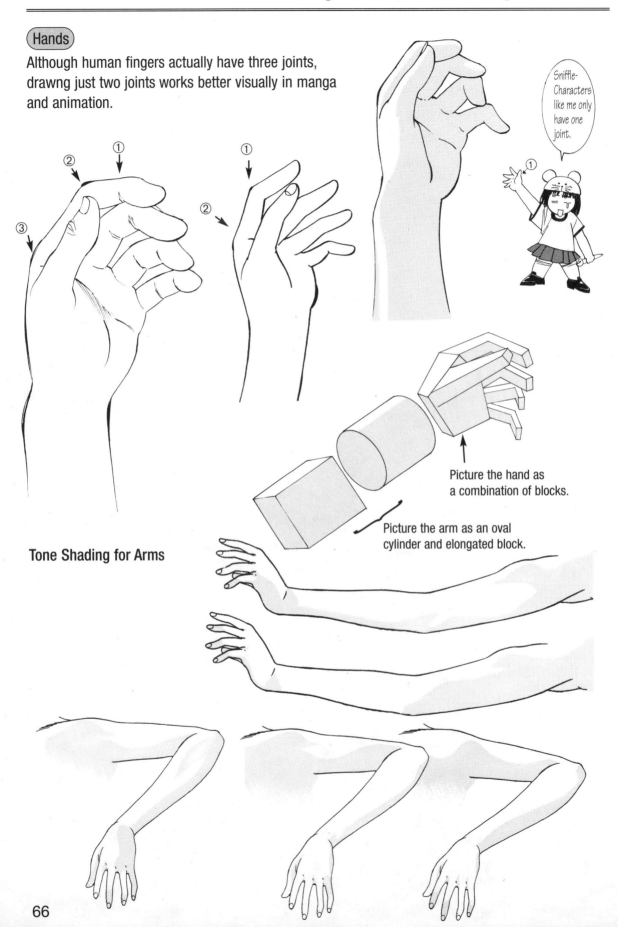

Sniffle-Characters like me only have one joint.

Picture the hand as a combination of blocks.

Picture the arm as an oval cylinder and elongated block.

Tone Shading for Arms

Legs and Feet

Legs and feet are difficult to depict accurately. Use the figures below as reference.

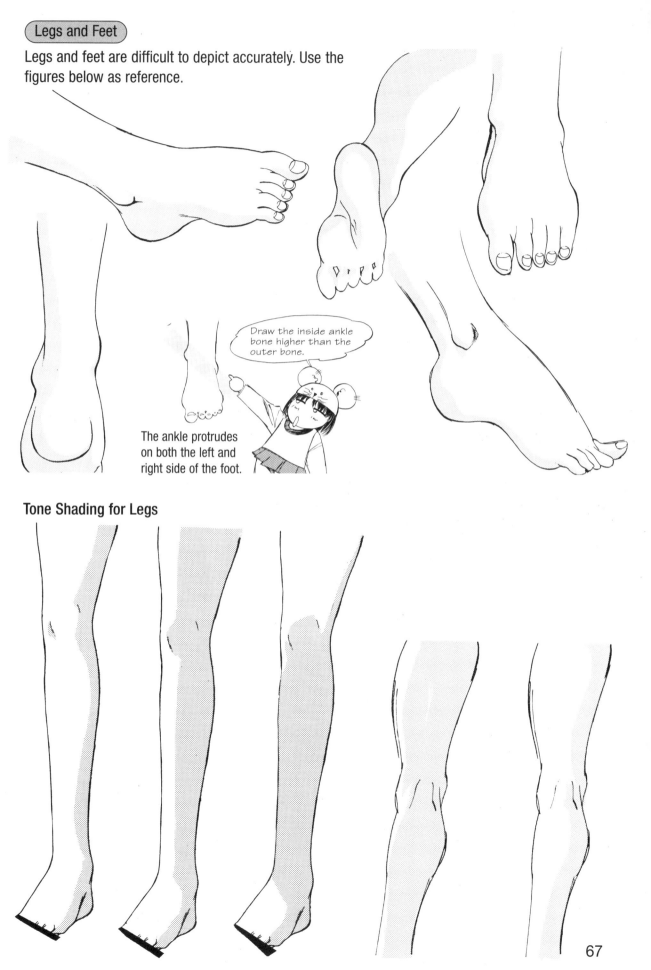

Draw the inside ankle bone higher than the outer bone.

The ankle protrudes on both the left and right side of the foot.

Tone Shading for Legs

The Underarm

This is not a readily visible body part, so it is difficult to check out how it is really put together. Use the figures below for reference.

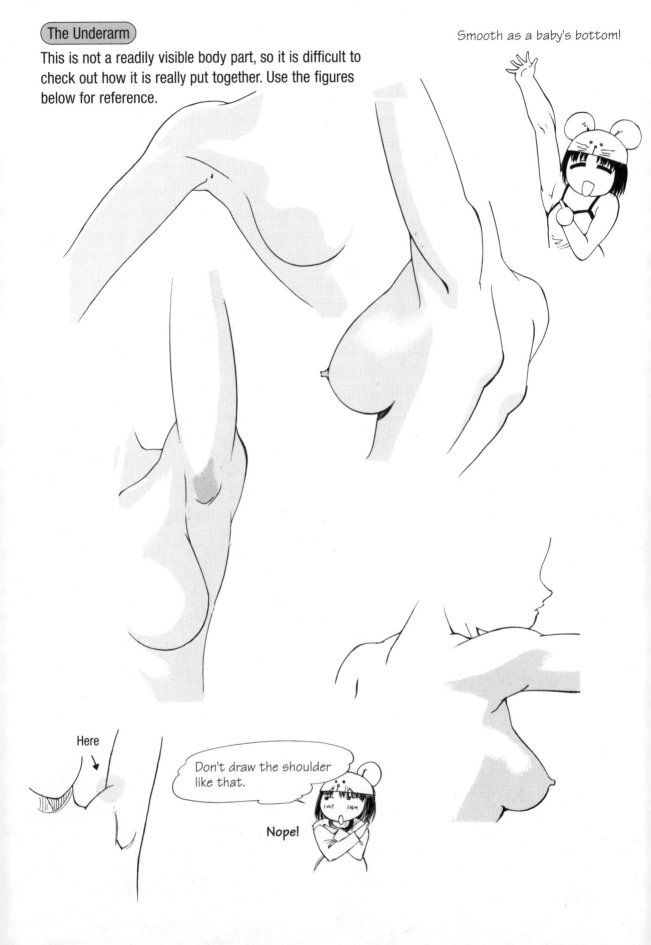

Here

Don't draw the shoulder like that.

Nope!

The Posterior

In manga, a close-up of the posterior usually constitutes a key panel. Consequently, care must be given to the placement of the tone.

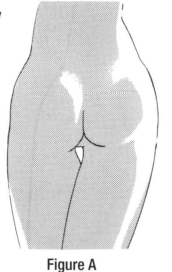

Figure A

Look at the way highlights and tone are used in Figures A through G. Shadows dominate in A and B. Highlighted areas must be positioned carefully and correctly. In C and D, tone was used to dramatically accentuate the posterior. Figure E shows a few audaciously placed highlights. In Figure F, the highlights in Figure E were retained, but shadows were added. Figure G was created based on a natural play of light and shadow.

Figure B

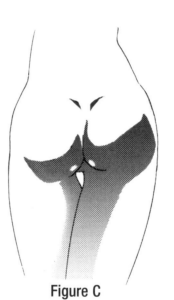

Figure C

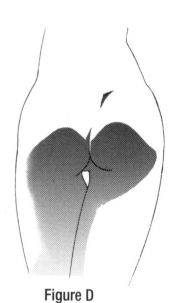

Figure D

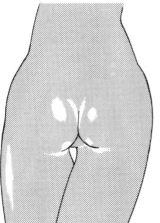

Figure E

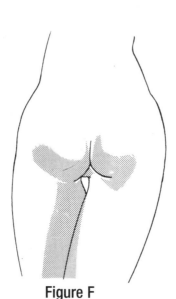

Figure F

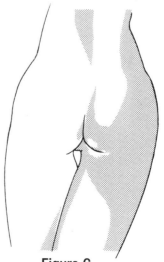

Figure G

Light, Shadow and the Female Form

Frontlighting

This is the standard light angle to use when adding just a touch of shadow. It is also the lighting that best shows off the character's face, but again, the features are accentuated by adding tone.

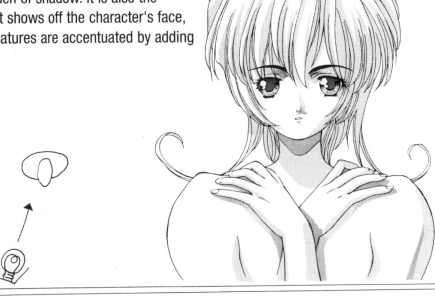

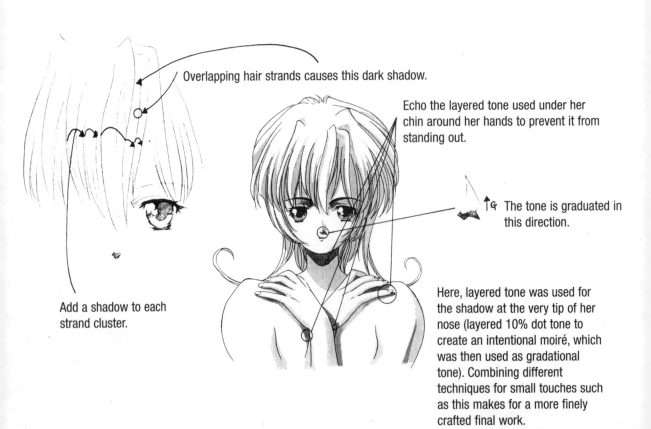

Overlapping hair strands causes this dark shadow.

Echo the layered tone used under her chin around her hands to prevent it from standing out.

↑G The tone is graduated in this direction.

Add a shadow to each strand cluster.

Here, layered tone was used for the shadow at the very tip of her nose (layered 10% dot tone to create an intentional moiré, which was then used as gradational tone). Combining different techniques for small touches such as this makes for a more finely crafted final work.

Frontlighting Shifted Slightly

Since frontlighting is so common, shift the light source slightly to the left or right to get a different flavor.

Areas such as these are hard to conceptualize as three-dimensional. Here, I experimented by using triangles.

Compared to the example on the previous page, this tone serves basically a visual function, but such shadows work well. Take care to maintain a sense of depth.

I didn't like the way the shadows on her nose balanced with those on her cheek, so I reduced them to make her nose appear smaller. However, if this figure were to be matched precisely with the one on the previous page, the shadows would have to be made about that size too.

These have taken a rectangular shape because her wrists were conceived as elongated boxes.

I expanded the shadow on her shoulder to balance the enlarged shadow on her cheek.

Minimize shadow here to prevent the artwork from appearing clumsy.

Rectangle

Well-suited toward dramatic tone work, this angle gives the subject more depth than frontlighting.

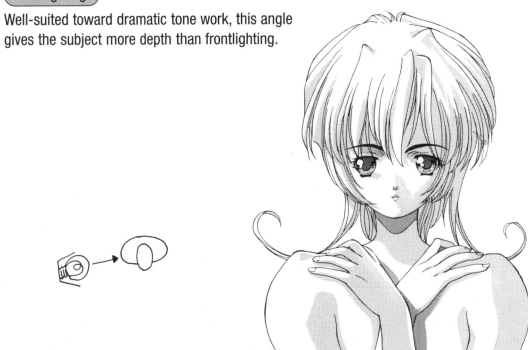

Skillful merging of the shadows around the nose and cheek is crucial to this angle.

Visualize the shadows around the nose and cheek as separate entities. I made the nose larger when I drew the value-separation lines for this figure.

To make the character more stylized, I decided to make the recessed area under her brow deeper and add shadow. The area near her temple is subtly highlighted by light.

The highlights around her eye are created by the light source off to the side.

I used perfectly overlapping tone to give her dark eyes. Full double would have muddled the clarity.

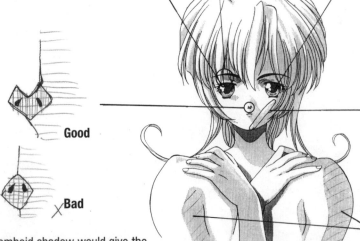

Good

Bad

A rhomboid shadow would give the character a pig-like nose.

Points A and B are connected.

Holding the shoulders in this manner causes them to shift forward. Considering the position of the light source, the shading seems appropriate.

This angle works well for creating dramatic hair highlights and for key scenes. However, it does tend to flatten the subject.

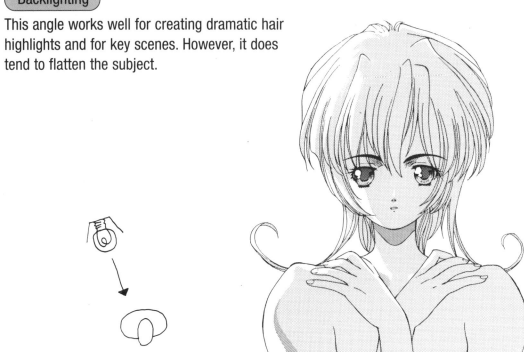

Backlighting is used to improve the final image by emphasizing reflected or haloed light. However, the key point to remember is that the front of the subject is in shadow. Keeping that in mind, I added flat shading.

This amount of outline etching is on the verge of being excessive. Take care not to use too much, since the hair around the front of her face is mostly in shadow.

Conceive of hair highlights as forming a nimbus around the character's head. When you etch the tone, imagine the light on the more exposed surfaces creeping and cutting into the shadow. Naturally, this is not limited to hair.

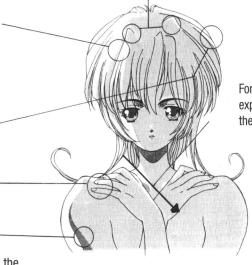

For further explanation, see the next page.

Light haloes her hair.

I initially felt that her ring finger should be touched by light, while her pinky would remain in shadow. Finally, I just put all of her fingers in shadow.

I made this light cut into the shadow to give the subject more depth.

In this case, the layering prevents unwanted blurring of countour lines by accentuating the areas where white meets tone. The position of this accent is the surface of the shoulder that juts out ever so slightly. Too much accent, however, will take on a clumsy appearance.

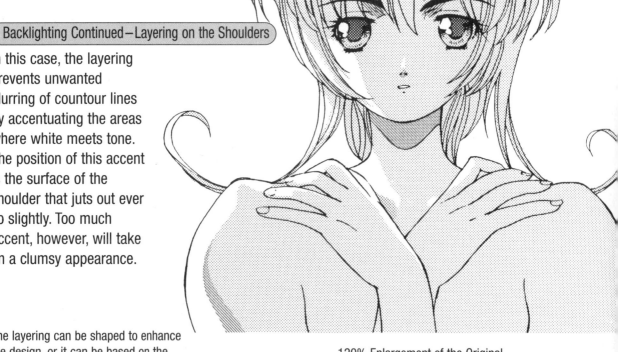

120% Enlargement of the Original

The layering can be shaped to enhance the design, or it can be based on the physical structure of the shoulder. In either case, ithe layering must function well as an accent. if the layering is too thin, the artwork will seem awkward.

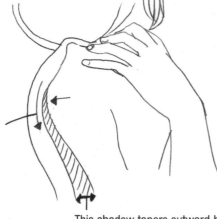

Add a precise, gentle curve.

This shadow tapers outward because less light would touch the lower area of her arm.

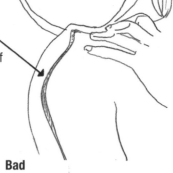

A thin, line-like accent makes for a clumsy image. Moreover, the risk of moiré increases.

Bad

Tone layered properly makes my skin radient.

Moiré makes my skin look icky.

Attractive female characters must have great skin!

Overhead Lighting (Painting-Style Tone Work)

What is "painting-style tone work"?

In this technique, screen tone is added following the same steps as when applying watercolors to a painting. As you can see, this involves adding all values of tone, from white to black.

The most important aspect is knowing how to handle gradational tone. You will need to develop the ability to look at a drawing and instinctilvely know which tones to use.

絵画貼り3コマ劇場

"Painting-Style Tone Work" in three easy steps

| 1 | Just as you would with a watercolor, start with a light value (usually #61). |

Cover the illustration with #61 tone.

| 2 | Gradually add darker values by layering tones. Use gradational tones generously and avoid large patches of a single value. Flat, solid patches of a single shade do not appear in watercolor paintings, nor should they appear in a manga illustration where the subject is bathed in overhead light. |

Then add darker tones one by one.

| 3 | As much as possible, blend the borders where two values meet. Make sure that borders featuring a dark value are particularly well blurred. |

That's all there is to it!

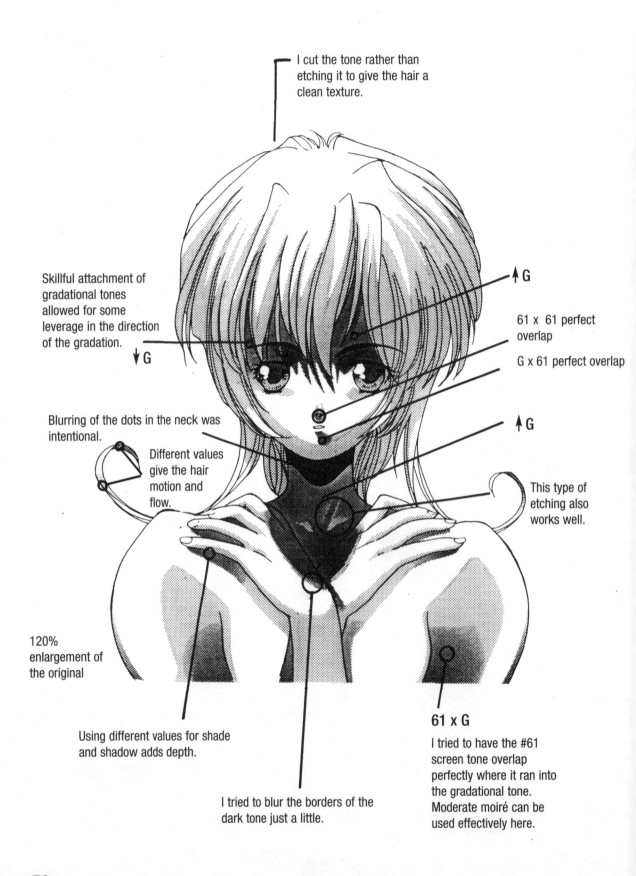

I cut the tone rather than etching it to give the hair a clean texture.

Skillful attachment of gradational tones allowed for some leverage in the direction of the gradation.

↓G

↑G

61 x 61 perfect overlap

G x 61 perfect overlap

↑G

Blurring of the dots in the neck was intentional.

Different values give the hair motion and flow.

This type of etching also works well.

120% enlargement of the original

Using different values for shade and shadow adds depth.

I tried to blur the borders of the dark tone just a little.

61 x G

I tried to have the #61 screen tone overlap perfectly where it ran into the gradational tone. Moderate moiré can be used effectively here.

Depicting Shadows on the Female Body

Tone #61 (60 lines, 10% density) is the one most commonly used for shading. Care must be taken when using gradational tone that the value is neither too light nor too dark for its placement and that it is properly aligned and not attached at an angle.

Shadows change depending on how a solid is rendered, even if the light source does not change. It is important to make use of imaginative shading as well as to have a basic knowledge of musculature. In other words, once you have daringly placed highlights around areas that would not be touched by light, or have distinguished various shadows despite using the same shading value, or have employed other audacious shading techniques that improve the appearance of your artwork, then you have achieved success.

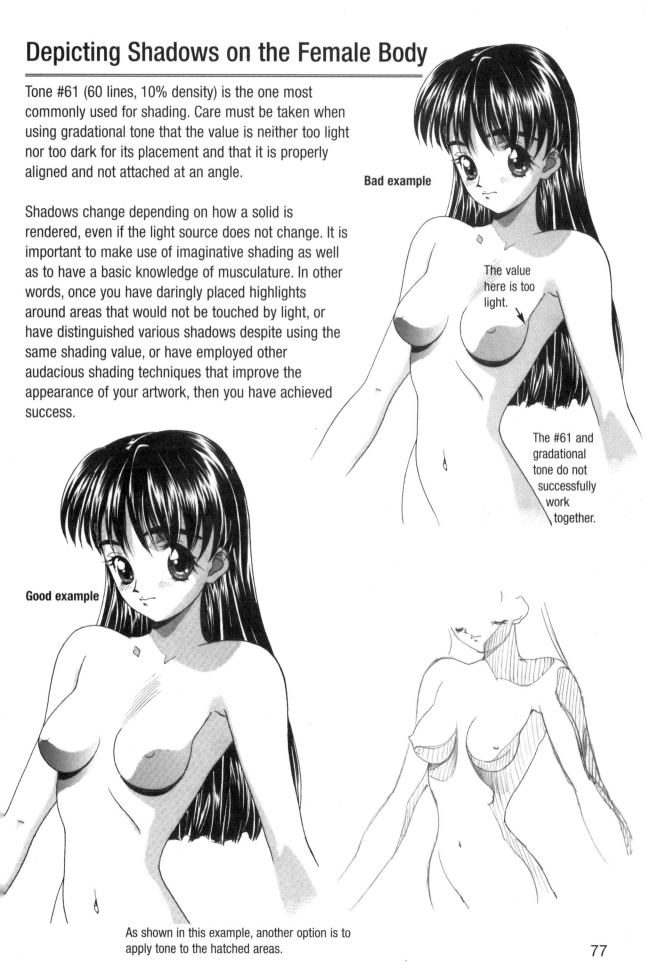

Bad example

The value here is too light.

The #61 and gradational tone do not successfully work together.

Good example

As shown in this example, another option is to apply tone to the hatched areas.

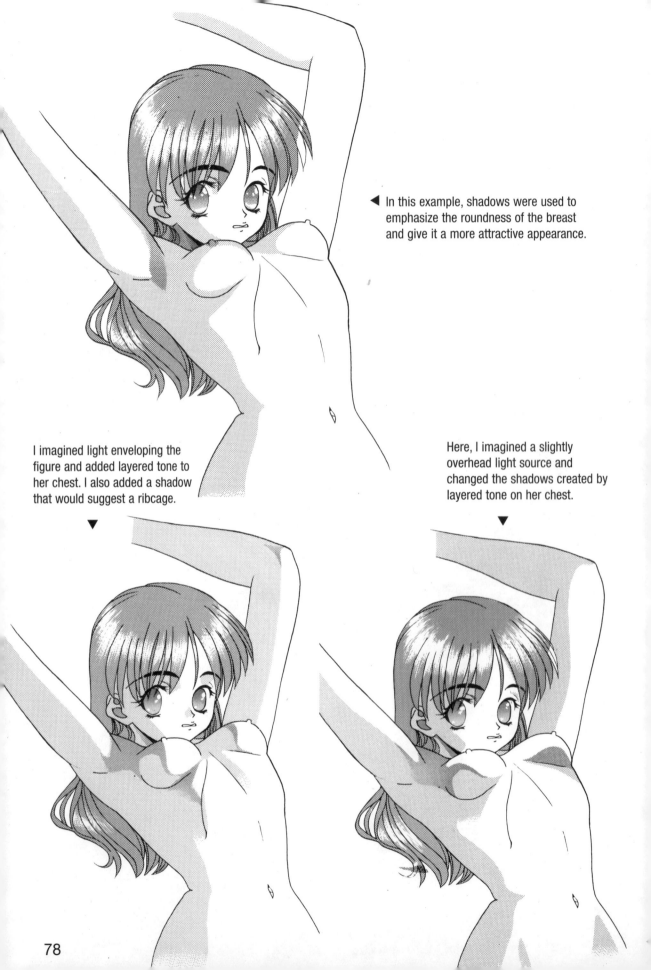

◄ In this example, shadows were used to emphasize the roundness of the breast and give it a more attractive appearance.

I imagined light enveloping the figure and added layered tone to her chest. I also added a shadow that would suggest a ribcage.

▼

Here, I imagined a slightly overhead light source and changed the shadows created by layered tone on her chest.

▼

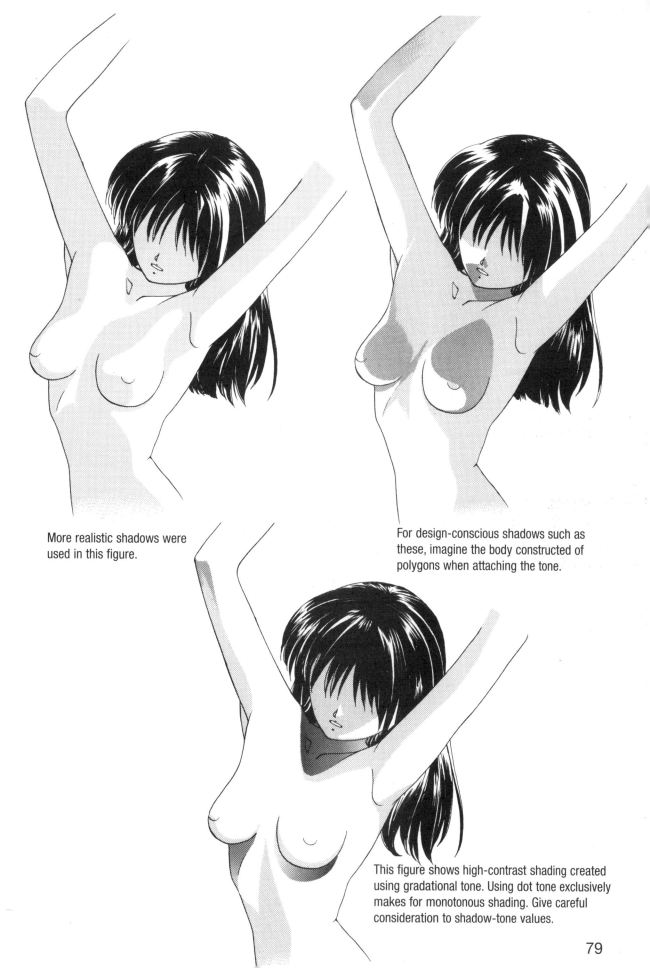

More realistic shadows were used in this figure.

For design-conscious shadows such as these, imagine the body constructed of polygons when attaching the tone.

This figure shows high-contrast shading created using gradational tone. Using dot tone exclusively makes for monotonous shading. Give careful consideration to shadow-tone values.

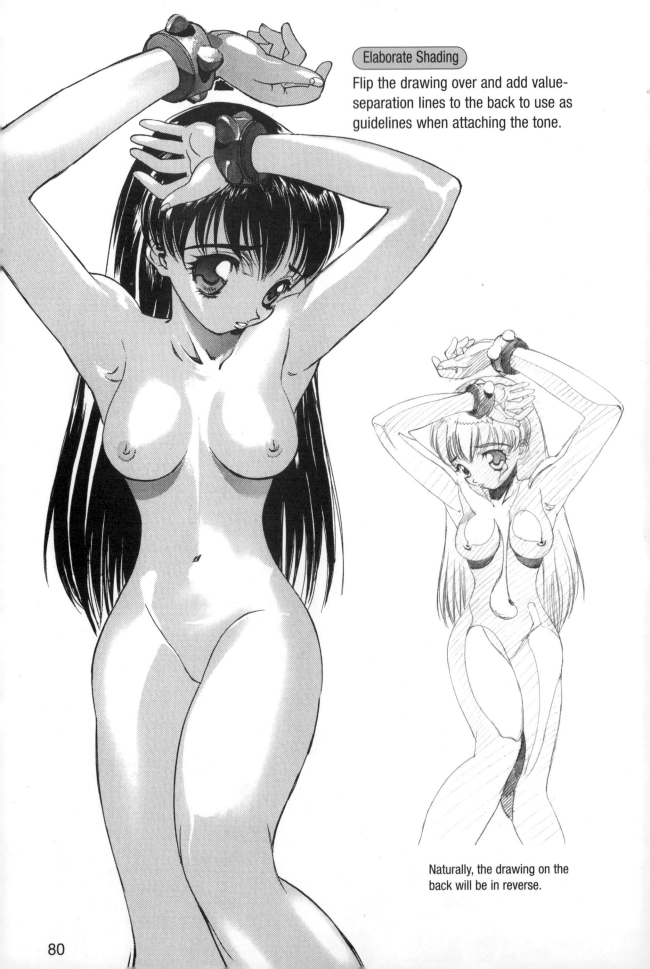

Elaborate Shading

Flip the drawing over and add value-separation lines to the back to use as guidelines when attaching the tone.

Naturally, the drawing on the back will be in reverse.

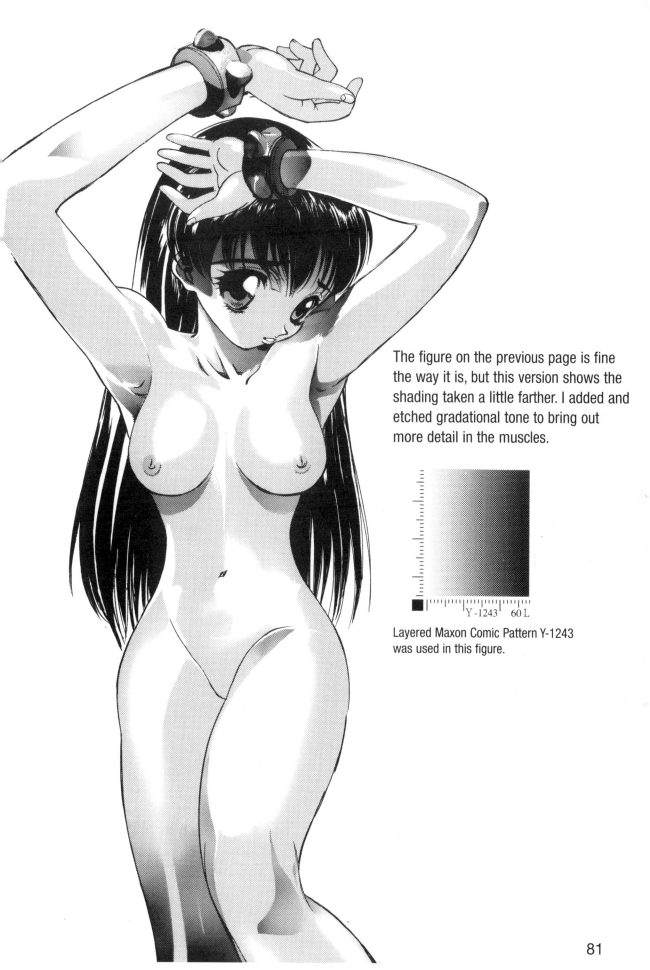

The figure on the previous page is fine the way it is, but this version shows the shading taken a little farther. I added and etched gradational tone to bring out more detail in the muscles.

Y -1243 60 L

Layered Maxon Comic Pattern Y-1243 was used in this figure.

Gradation Using a Single Tone

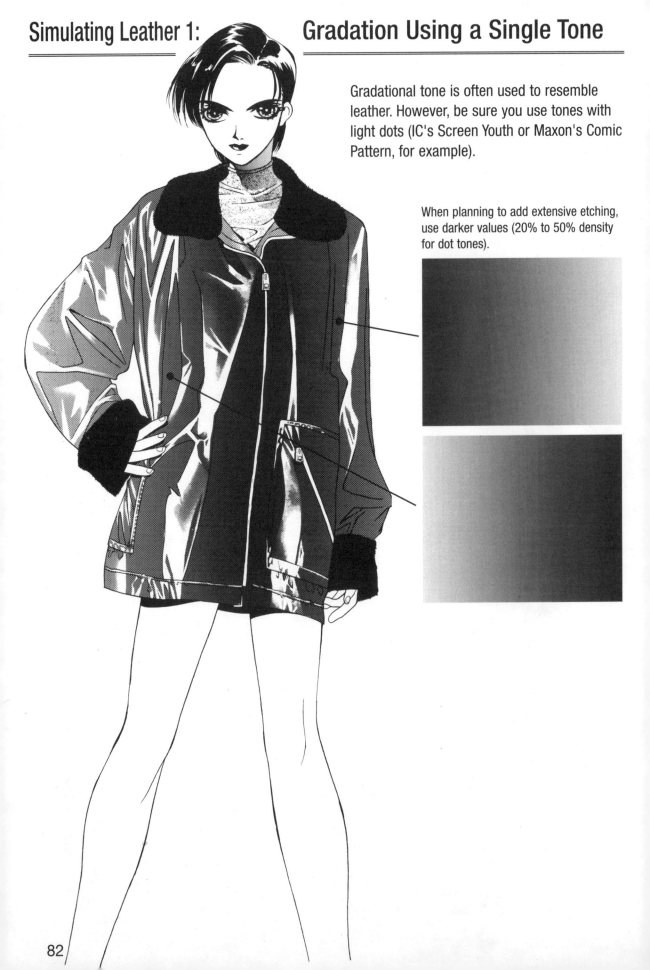

Gradational tone is often used to resemble leather. However, be sure you use tones with light dots (IC's Screen Youth or Maxon's Comic Pattern, for example).

When planning to add extensive etching, use darker values (20% to 50% density for dot tones).

Etch the areas on the surface of the jacket that reflect light.

Also use etching to highlight creases and folds in the garment.

Think triangular: Etch around a triangle, or completely etch away such a shape.

Etch away the tops of the rolls in the turtleneck.

Rolls of the turtleneck

Adding a thin area of reflected light to a large patch of shadow creates an effective accent.

Leaving some of the tone untouched is also effective.

Also leave areas in shadow untouched.

Conversely, fully etch away tone in areas touched by light.

Don't go overboard, though. Take care not to encroach on areas of shadow when etching.

G G
The placement of tone was skillfully executed in this drawing.

Dark tone was used here in anticipation of some blurring occurring in the dots.

Using a sand eraser to lighten the tone works well. The detail is enhanced with a few rubs of the eraser.

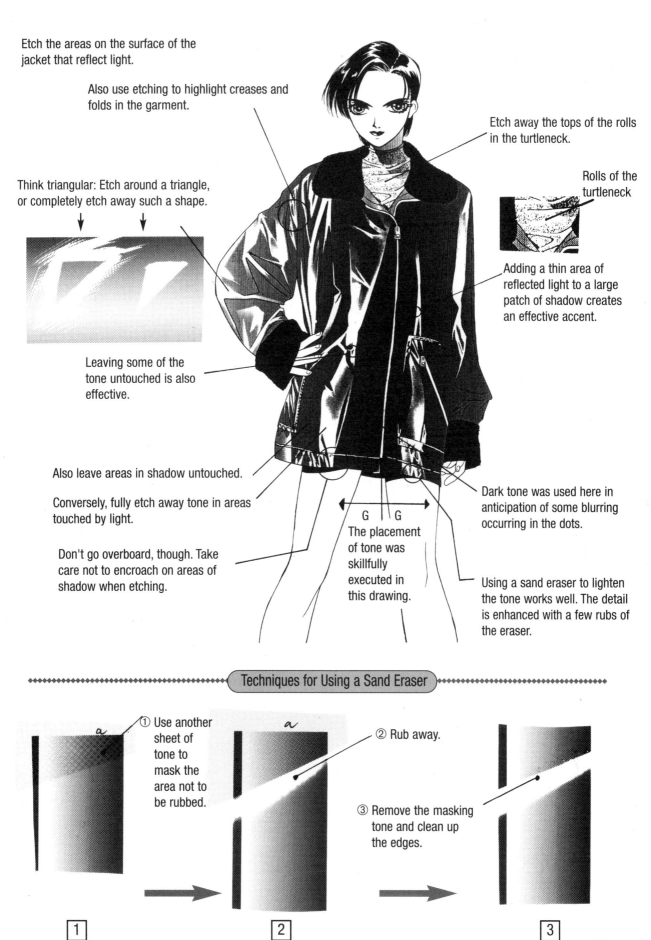

Techniques for Using a Sand Eraser

① Use another sheet of tone to mask the area not to be rubbed.

② Rub away.

③ Remove the masking tone and clean up the edges.

1

2

3

汝等人間は神の創造した最大の「失敗作」

故に

人間は全て処分せねばならない

断つ刻が来たのだ!!!

From "Bastard!! Dark God of Destruction"
© Kazushi Hagiwara, Shueisha Inc.

Simulating Leather Using a Single Gradational Tone

Suggest texture simply by etching.

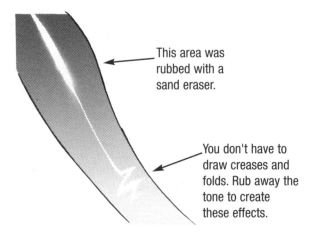

This area was rubbed with a sand eraser.

You don't have to draw creases and folds. Rub away the tone to create these effects.

① Use a sand eraser to add bokashi effects.

② Next, add sharp etches with a craft knife.

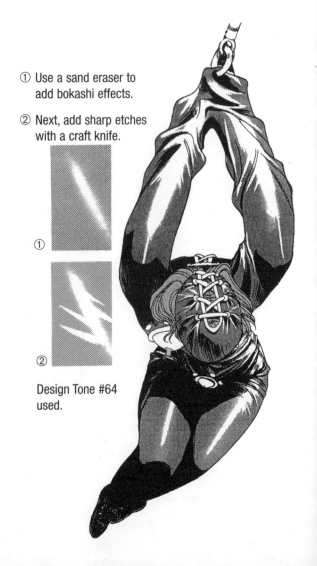

①

②

Design Tone #64 used.

The most common alignment of tone is based on the 45-degree angle of the dots. However, in the case of leather of this sort, it is extremely difficult to achieve a satisfactory value by aligning the tone along this 45-degree angle. However, even when forced to affix the tone at an unusual angle, keep it as close as possible to this perfect alignment.

85

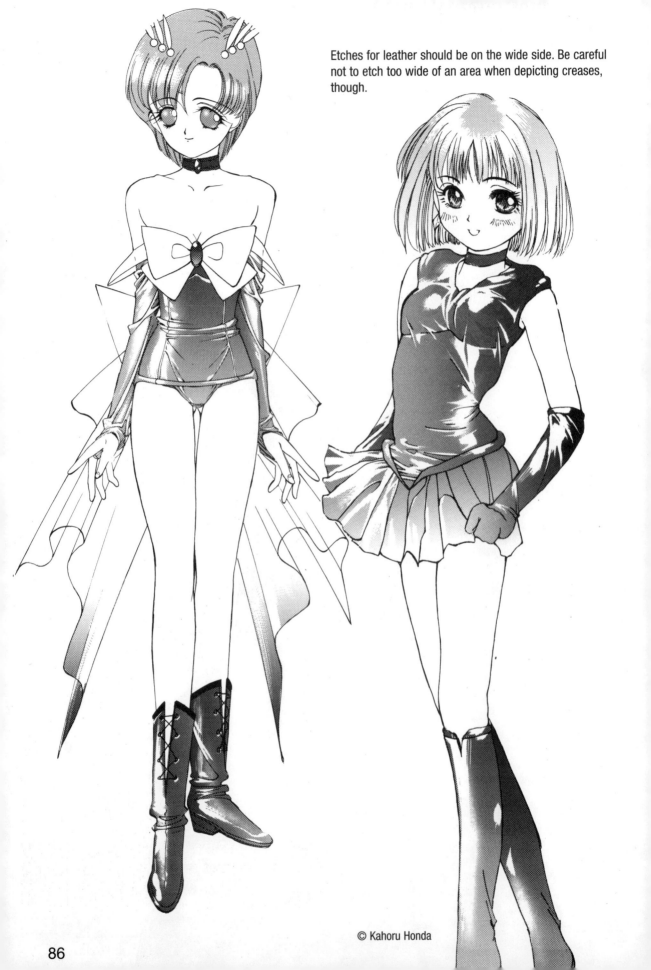

Etches for leather should be on the wide side. Be careful not to etch too wide of an area when depicting creases, though.

© Kahoru Honda

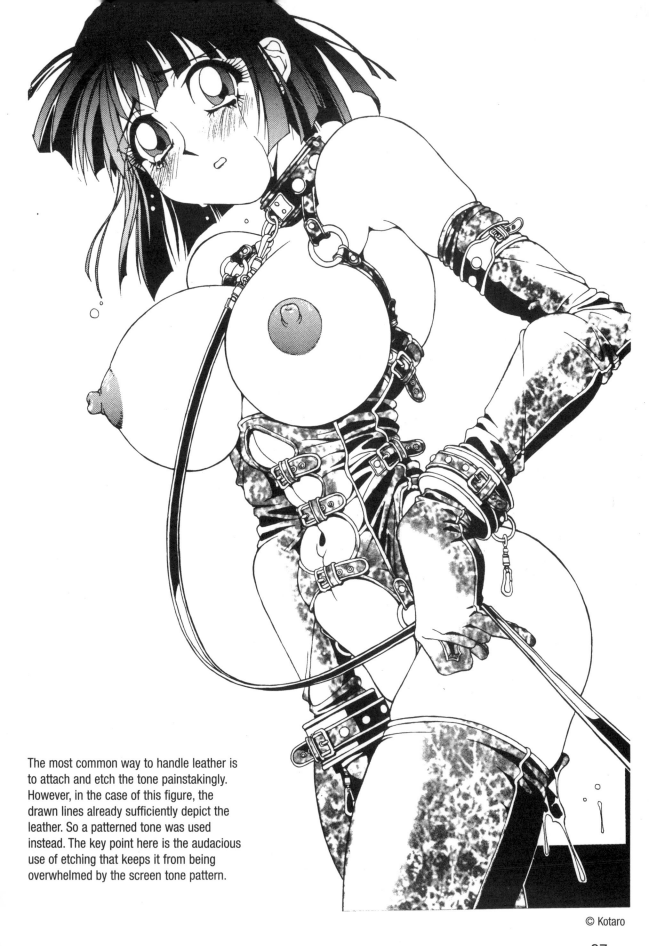

The most common way to handle leather is to attach and etch the tone painstakingly. However, in the case of this figure, the drawn lines already sufficiently depict the leather. So a patterned tone was used instead. The key point here is the audacious use of etching that keeps it from being overwhelmed by the screen tone pattern.

© Kotaro

Etching gradational tone alone works
extremely well for simulating leather. Still,
even more impressive leather effects can be
created by layering the tone.

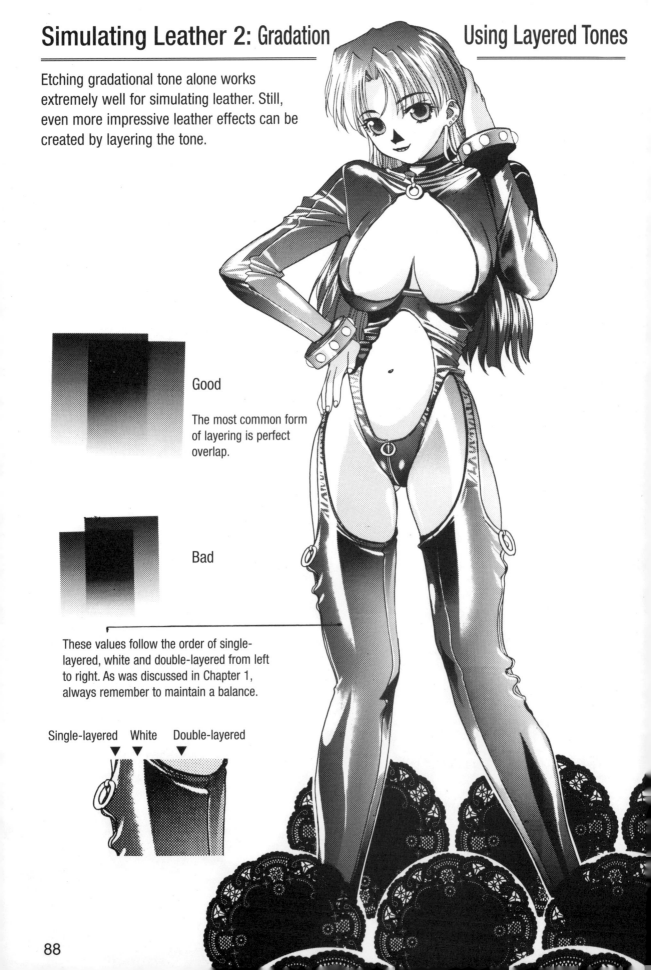

Good

The most common form
of layering is perfect
overlap.

Bad

These values follow the order of single-
layered, white and double-layered from left
to right. As was discussed in Chapter 1,
always remember to maintain a balance.

Single-layered White Double-layered

Simulating Leather Using Layered Gradational Tones

From "Bastard!! Dark God of Destruction" © Kazushi Hagiwara, Shueisha Inc.

Do I look hot, or what?

It is difficult to use dark tone of 30% density or greater. However, a sense of supreme satisfaction is gained when layered areas of tone for leather, added to create the same blackness as pencil lead, all come together successfully.

Placing and Etching Tones for Clothing

Use a non-photo blue pencil to draw the value-separation lines for creases in clothing. Add shadows along the lines.

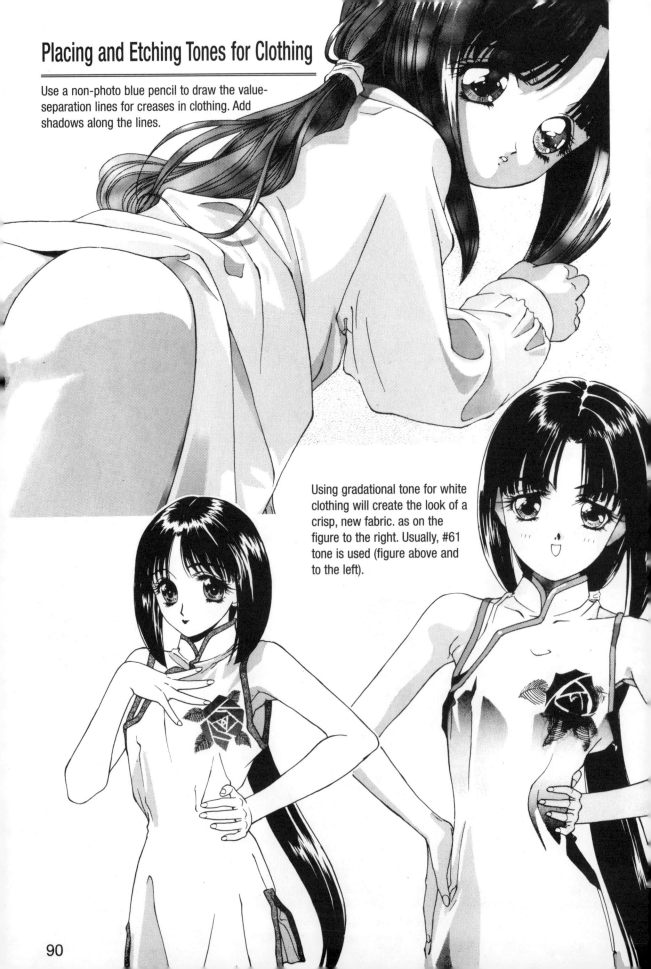

Using gradational tone for white clothing will create the look of a crisp, new fabric. as on the figure to the right. Usually, #61 tone is used (figure above and to the left).

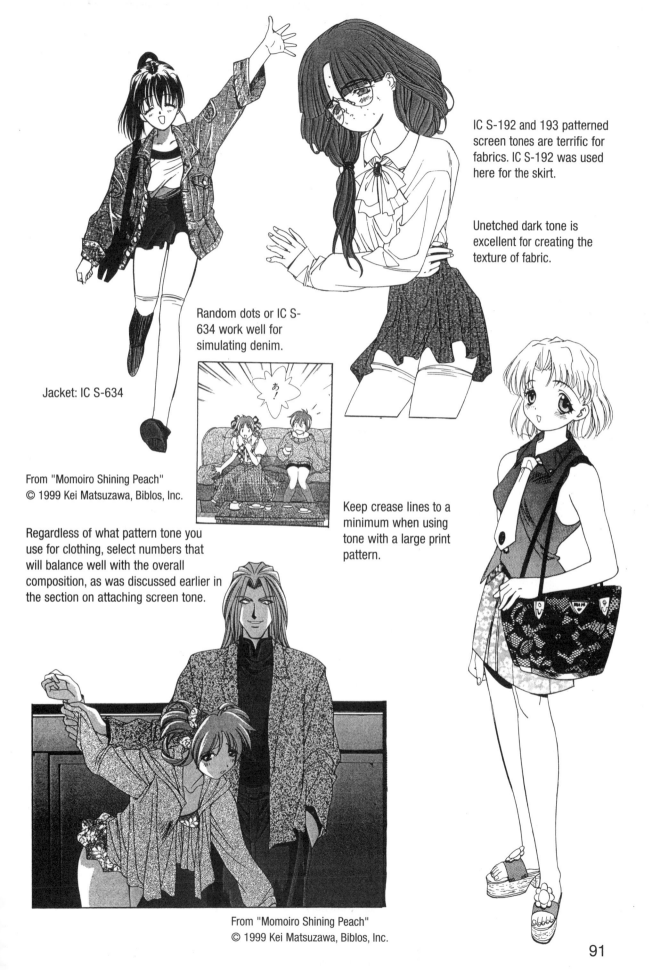

IC S-192 and 193 patterned screen tones are terrific for fabrics. IC S-192 was used here for the skirt.

Unetched dark tone is excellent for creating the texture of fabric.

Random dots or IC S-634 work well for simulating denim.

Jacket: IC S-634

From "Momoiro Shining Peach"
© 1999 Kei Matsuzawa, Biblos, Inc.

Keep crease lines to a minimum when using tone with a large print pattern.

Regardless of what pattern tone you use for clothing, select numbers that will balance well with the overall composition, as was discussed earlier in the section on attaching screen tone.

From "Momoiro Shining Peach"
© 1999 Kei Matsuzawa, Biblos, Inc.

91

This sort of vine-patterned tone is also popular for clothing.

A dark gradational tone was used here for her tights, giving the drawing an elegant look.

Always flip the drawing over and draw guidelines when using a pattern tone for socks.

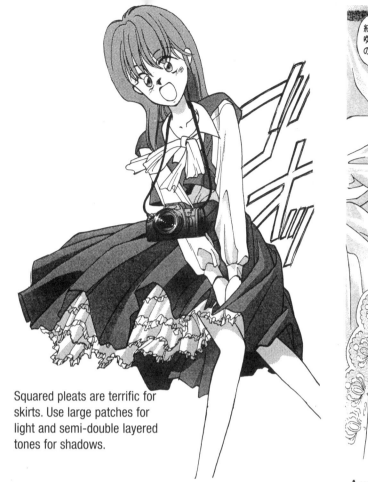

Squared pleats are terrific for
skirts. Use large patches for
light and semi-double layered
tones for shadows.

紅茶飲みながら
ゆるゆる読書する
のは最高ね

A wonderful texture has been produced here by
semi-doubling two gradational tones.

ほわ

For bed sheets, avoid
outline etching drawn
lines, and instead etch
the tone boldly in broad
patches.

Step-by-Step Tone Work

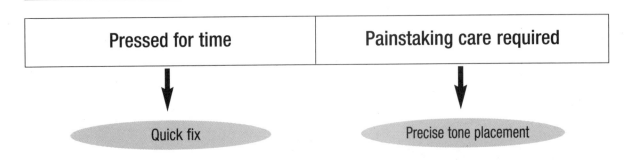

Pressed for time	Painstaking care required
↓	↓
Quick fix	Precise tone placement

Select the base tone

So many to choose from—large dot, regular dot, random dot, gradation tone, etc.

What are the primary areas to etch and how?

Add extra tone and etches

- Add white tone
- Add layered tone
- Use sand erasers, etc.

Add White

- Add white to areas depicting light
- Touch up tone extending outside of lines
- Spatter

Finished!

Now let's take a look at how these steps apply to a shower scene.

Shower Scene

Pressed for time

↓

Quick fix

↓

Select the base tone: Large dots

↓

What are the primary areas to etch? Steam.

↓

Add a few extra etches

↓

Add white

↓

Finished!

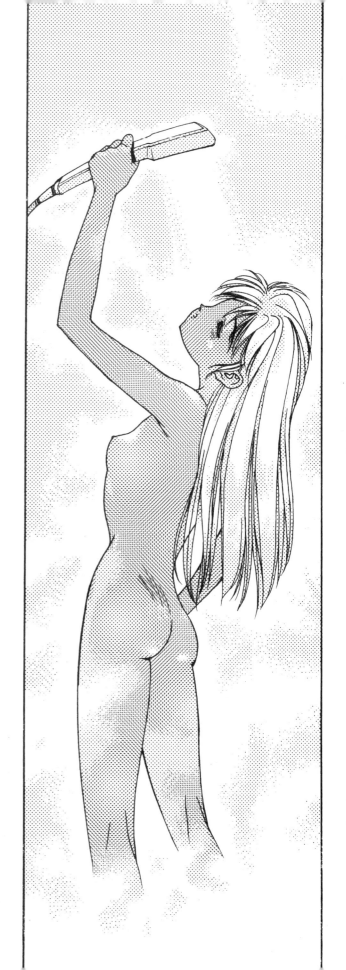

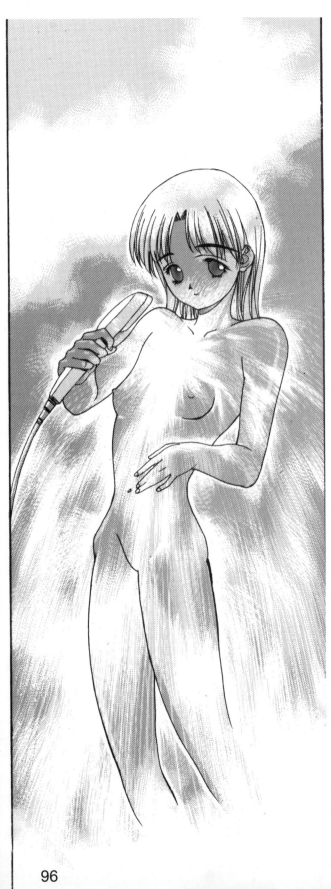

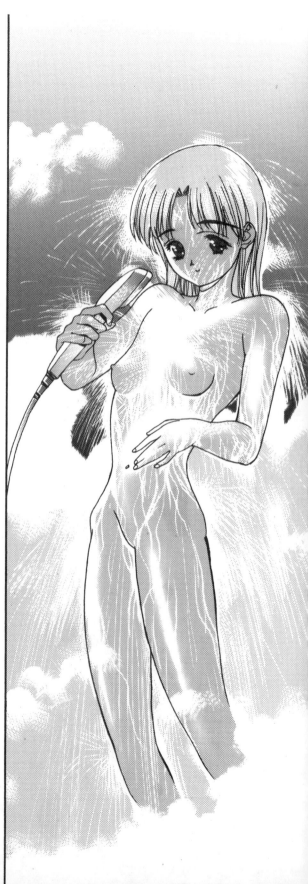

Quick Fix

This technique involves a single sheet of tone (notwithstanding the character or the background). In this example, layered #61 tone was used. The etches primarily depict the shower water and spray deflecting off the character's body.

Precise Tone Placement

Each part of the illustration is allocated its own tone [e.g. hair (#61), skin (#62) background (graduated tone), eyes (#62 gradational tone), etc.]. The majority of etches serve to depict water cascading over the character's body.

These etches were made using an aluminum straightedge. Single-stroke etches are scattered throughout.

Spattered white ink

Sunakeshi technique (sand eraser used)

IC S-434

IC S-442

Harakezuri (patch etching)

Tone Work for the Figure to the Right

The etches are primarily used to represent steam. White, used to depict water droplets, was spattered throughout and then large white dots added as a finishing touch.
The key point is the intentional placement of large, white dots on drawn contours to break the lines' continuity.

The flicking and splattering of white is called "spattering."

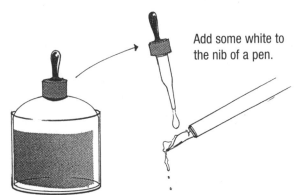

Add some white to the nib of a pen.

[1] White Design Ink or Dr. Ph. Martin's Pen White

Diluted white Animex also works well.

Why is selecting the base tone so important? Take a look.

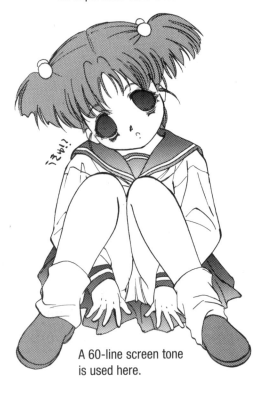

A 60-line screen tone is used here.

Spattering Technique #1

Using a hard-bristled brush

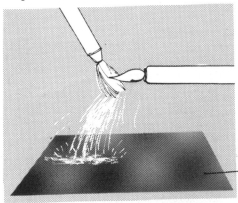

The original sketch

Stroke the pen nib with the brush, spattering the white ink over the sketch.

Spattering Technique #2

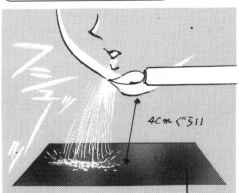

Approx. 1.5 inches

Blow on the pen nib so that the white ink spatters on the drawing. The pen should be kept approximately an inch and a half above the sketch.

The original sketch

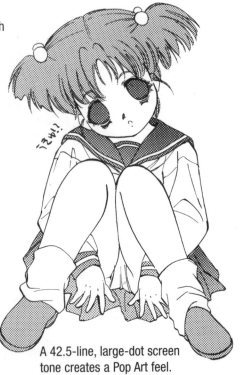

A 42.5-line, large-dot screen tone creates a Pop Art feel.

Chapter 3
Character-Enhancing Backgrounds

Tones can be used to create a wide range of background effects, ranging from clouds and rays of sunlight slicing through the branches of trees to mist and smoke and lightning. I will also dicuss digital tones, which can be used for even more amazing background effects. With just a little imagination, you will be able to bring your characters to life. By all means, experiment!

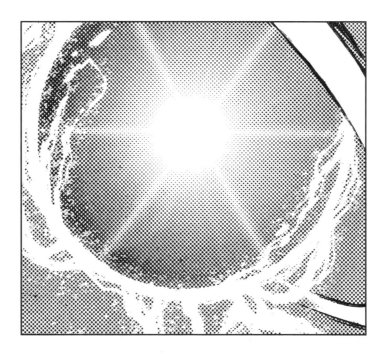

Water Spray

Make rough etches to show the primary flow of the water, then use smaller strokes to represent spray droplets.

Cherry Blossoms

Placing flowers in the corner of a composition is a great finishing touch. Using vigorous strokes following the flow of the petals to etch out a patch of tone works well, and including areas of harakezuri also produces desirous effects.

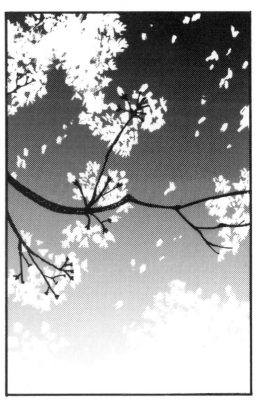

Close-up of water spray

Close-up of cherry blossoms

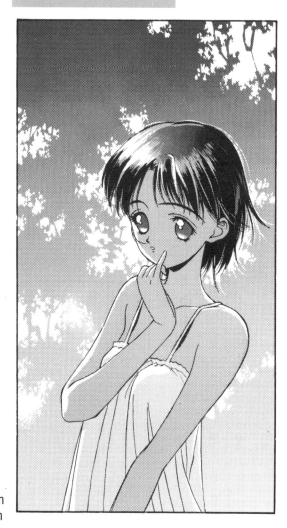

Highlights surrounding the silhouette of a character are called halos, and manga artists can often be found instructing their assistants to etch a backlit halo around a character. Take care that the halo does not grow into outline etching. For creating sunlight through trees, build up triangles in the desired pattern and etch.

Something like this.

Close-up of sunlight through trees

Clouds

Clouds are relatively simple to create using tones. Just keep etching until you have achieved the desired look.

Something like this works well.

Single-stroke etching was used here.

A sand eraser did the trick.

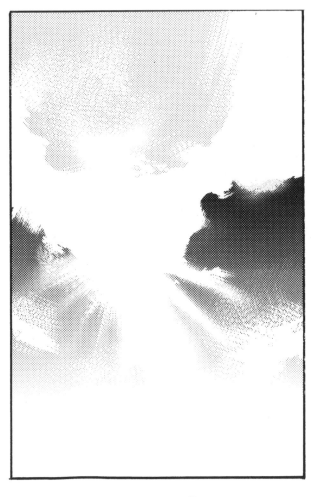

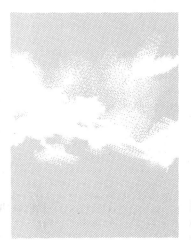

For small panels, IC 61 etched normally produces satisfactory results.

Keep the strokes light and natural. Maintain an awareness of perspective when etching.

This is how they appear when looking skyward.

Spring Clouds

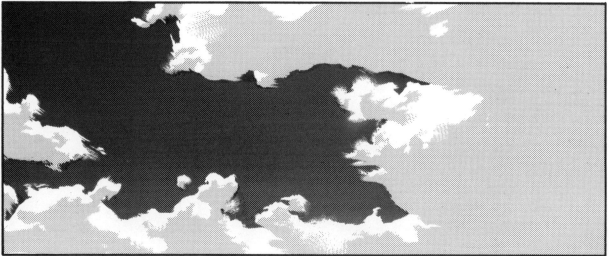

Summer Clouds

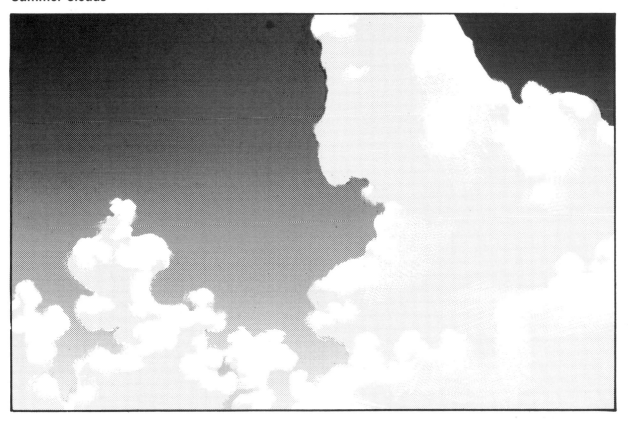

Use bold etches to depict drifting, fluffy clouds.

Total shadow

Light reflects off of each orb like this.

Scattered patches etched like this will improve the look of the clouds.

Autumnal and Wintry Sky

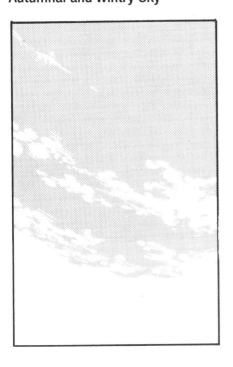

Wispy clouds such as these are produced by repeating small strokes.

Moon with Clouds at Sunset

First use a compass to draw a circle on the tone or flip the illustration over and draw one on the back. Then, etch away the tone using a craft knife.

Night Clouds

Mmm...I just love the night.

These are produced using perfectly overlapping gradational tones.

Creating Dramatic Clouds

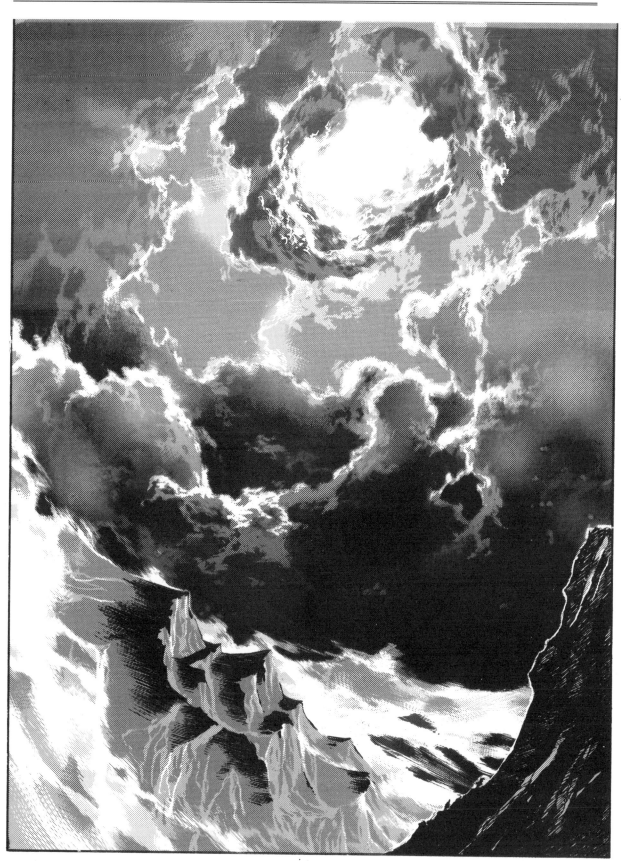

Completed work

Turn the page to learn how to create dramatic clouds such as these.

Form the clouds one by one while picturing the final image in your mind. The base screen tone used here is IC Youth 1061.

The initial shaping of the clouds will affect the final image, so careful consideration must be given toward how you will first proceed, such as whether to double- or triple-layer the screen tone.

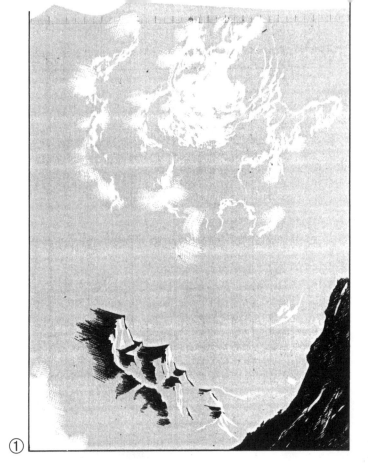

This is the completed first layer.

Once the general shape of the clouds has been set, the rest can be etched with relatively less prudence.

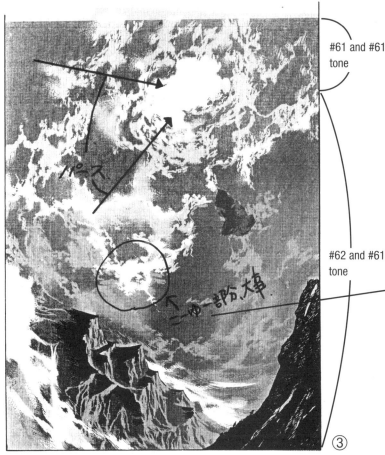

#61 and #61 tone

Add the second layer of tone. Etch the clouds while maintaining a sense of perspective.

Different tones were used to suggest perspective for each large cloud cluster.

#62 and #61 tone

This part is important.

I selected white for the rolling clouds near the bottom of the image to make the dark mountains stand out.

③

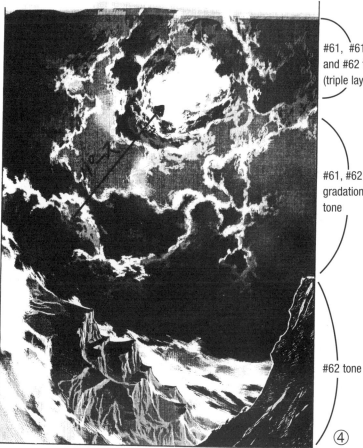

#61, #61 and #62 tone (triple layer)

The image has become fairly dark with the addition of the third tone layer, and may not look good when printed in a manga magazine, so it might be better to revert to two layers. That said, the muddying of darker layers of gradational tone for this work is acceptable.

#61, #62 and gradational tone

At this point, the work is almost complete. A little detailed etching should be added.

#62 tone

To avoid having this area appear muddy after being printed, I used a single-layered tone here.

④

107

Special Effects

Manga are always filled with explosions, smoke and other exciting effects. Using digital screen tones won't always do the trick, though, so make the most of the etching techniues you have learned to create your own special effects.

Krack!
Eeeek!

1. Lightning

Lightning is also referred to as "flashes" or "sparks." The key to creating lightning is not to etch along a straight line, but to make it zigzag. Take care when etching streaks.

*What are streaks?
Streaks are etches that follow the main line of the lightning bolt.

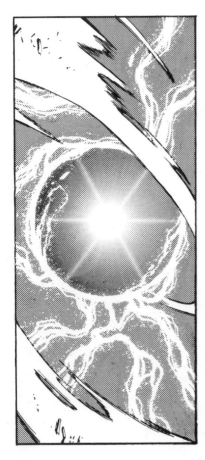

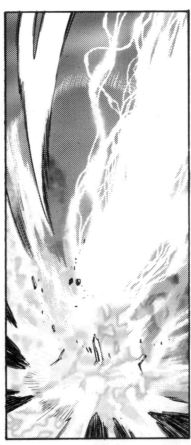

Steps for Creating Lightning

① First, etch the main bolt.
② Next, use a sand eraser to rub away streaks.
③ Finally, add a random white-dot tone and spatter white ink on the work.

The Main Bolt

This sort of complicated lightning can be created if given the proper effort.

①

②

③

2. Light

There are many ways to depict light, but they are all based on the same basic techniques. Figures A through F were all created in the same manner: The center of the light source was established, and then the tone was etched in radiating strokes.

A
This is the most common and easiest way to delineate light. Arrows show the direction in which the tone should be etched.

Etchings are added in evenly spaced, radiating strokes.

B & C
These were created simply by adding dot tone after sketching the illustration using India ink. The etchings were added as indicated in the diagram below.

A

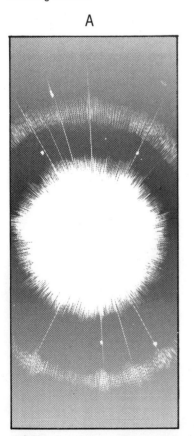

B

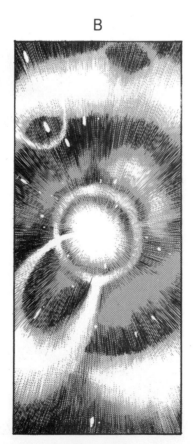

C

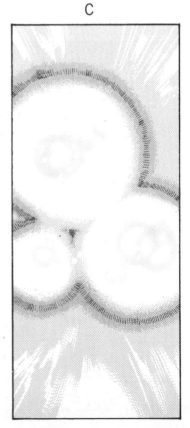

E & F

These were created using a digital screen tone. Smoke was added to E while multiple light sources were added to F. Always add your own personal touch, even when using computer-generated tones.

D

Make the changes as suggested in the vector diagram below.

What is a vector diagram?
A vector diagram shows the direction and strength (and in this case, the length) of the strokes.

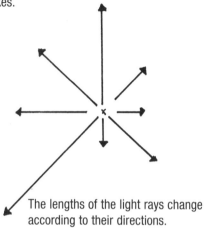

The lengths of the light rays change according to their directions.

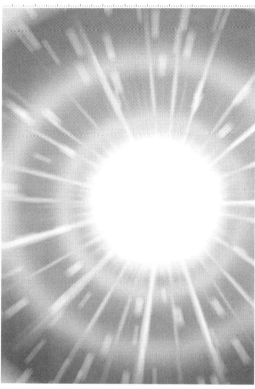

Unaltered Digital Screen Tone

Created using an aluminum straightedge.

D

E

F

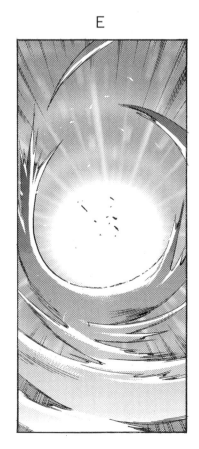

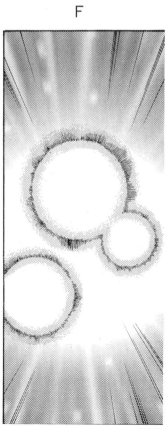

3. Smoke

There are many techniques for creating smoke, but all of them are based on the same basic concept: Etch the "surface" of the smoke using bold, sweeping strokes.

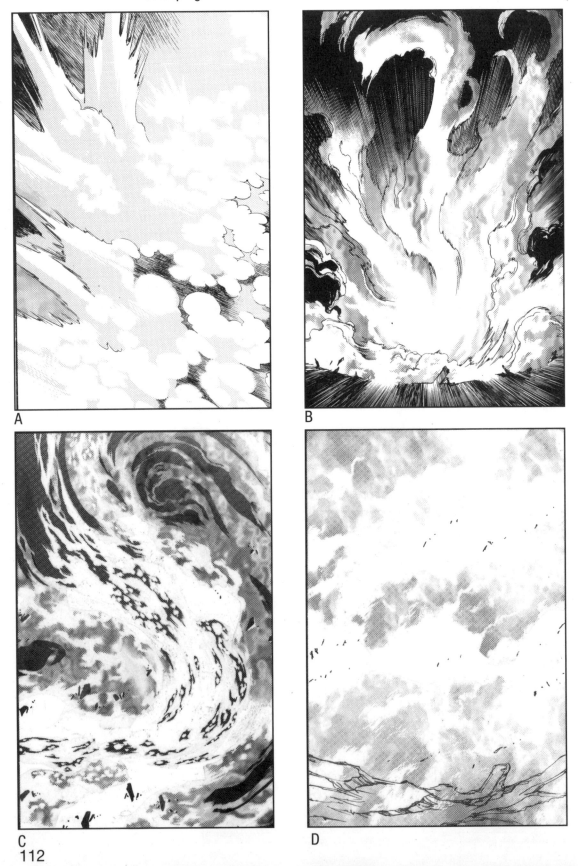

A

B

C

D

A
As with clouds, think of the smoke as solids when etching.

B & C
The arrows of the vector diagram for smoke are similar to those for light, except they are wavy instead of straight.

D
A smoky atmosphere was created simply through the placement of different tone values.

Examples of Good and Bad Tone Work

A. Outline etching prevents "surfaces" from appearing in the smoke. The work lacks boldness.

B. This is how a smoky landscape will look when tones are properly used.

Key Points in Smoke Tone Work

①

Figure 1 shows an inked drawing on the reverse side of the original illustration. Non-inked flashes and sparks are also depicted. The purpose for sketching on the back of the drawing is to gain a sense of the final work. Always make a copy of the sketch.

▲

Flashes and Sparks

Although perspective may seem irrelevant to this work, it is nevertheless included. Always be conscious of perspective in your tone work.

Foreshortening is used to give perspective to the drawing.

②

Tone work begins in the areas with the largest surfaces.

Tone was attched to this area first since it is the broadest.

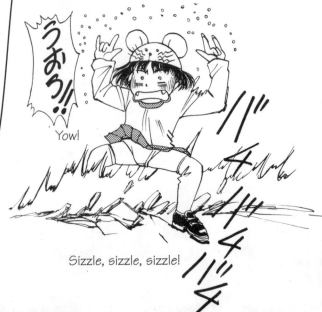

うおっ!!
Yow!

ハ゛
Sizzle, sizzle, sizzle!

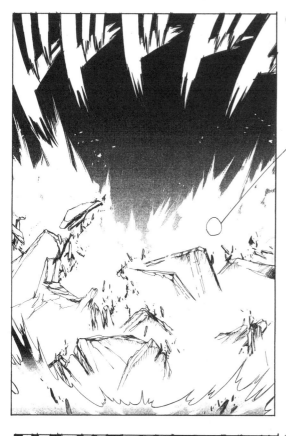

③ Flashes and sparks were etched using the flash technique.

This broad patch was left untouched, with the intention of adding shading for smoke afterward.

To reiterate, flashes and sparks refer to areas of light such as this.

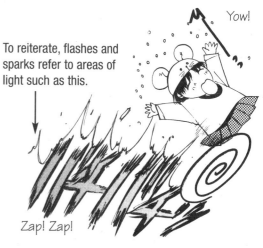

Yow!

Zap! Zap!

④ Tones were attached one by one to each rock, and then flashes and sparks were etched according to the guidelines on the sketch on the back of the original drawing. Use a copy of the initial sketch as reference.

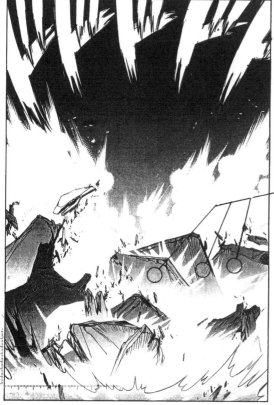

Rocks are normally distinguished through different tone values. However, go ahead and use etching to distinguish rocks where possible. In the figure to the left, etching was used to distinguish the three rocks, which have the same tone value. If the rocks have basically the same height and are the same distance from the picture plane, then it is not necessary to insist on using different values. Instead, use etching to differentiate the rocks.

⑤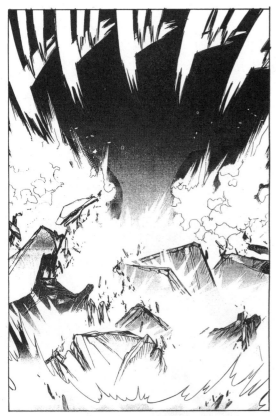

Shading for smoke is usually created using a light #61 tone. Sketch the smoke on top of the tone (note that these guidelines can also be sketched on the reverse side of the drawing and then photocopied for future reference). Mark those areas to be etched with an "X" so you won't have trouble recognizing where to etch.

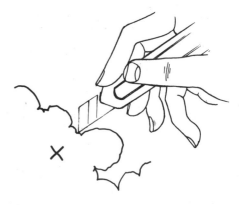

⑥

Shading for smoke generates a sense of distance. Since different values create this feeling of depth, use #62 tone, which is one step darker than #61, for smoke close to the picture plane, and gradational tone for even closer smoke.

Take care to prevent the smoke from becoming too monotonous.

#62 tone

Gradational tone

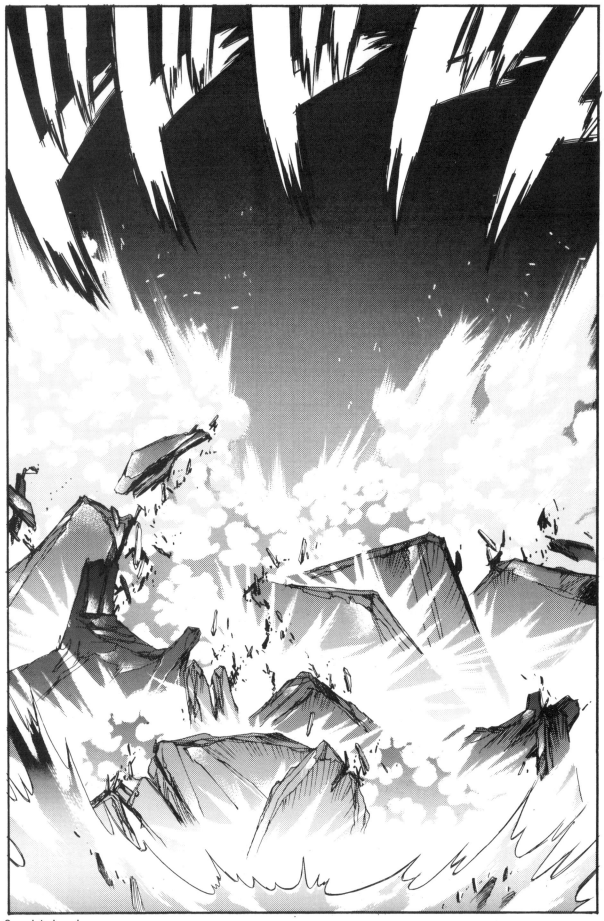

Completed work

Backgrounds to Enhance the Characters

To bring together the background flowers and the close-up of the character in a dramatic manner, the areas where the line-drawn flowers overlap with the close-up were etched away. Digital screen tone was used for the clothing worn by the character along the right side of the illustration. Bokashi and kakikezuri were used here.

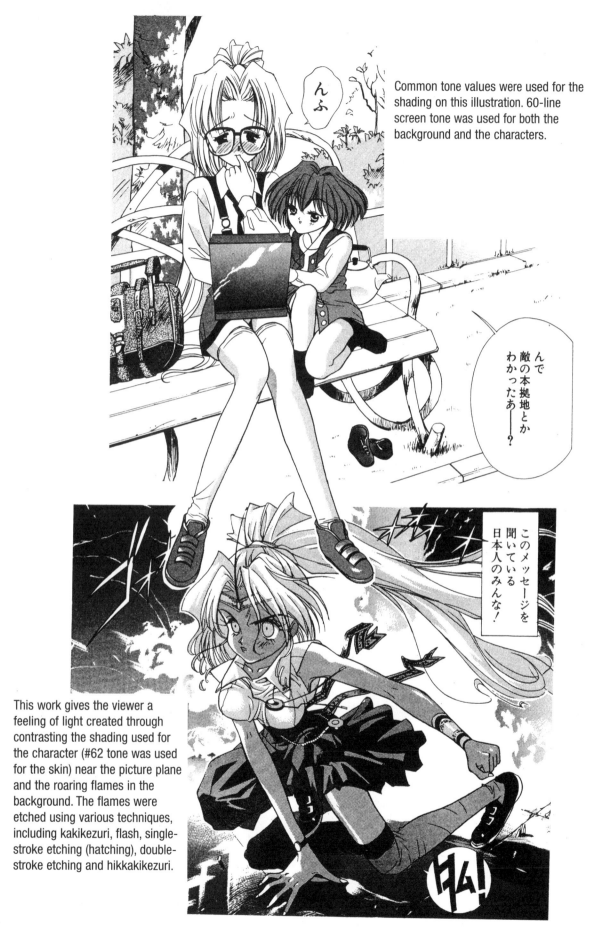

Common tone values were used for the shading on this illustration. 60-line screen tone was used for both the background and the characters.

This work gives the viewer a feeling of light created through contrasting the shading used for the character (#62 tone was used for the skin) near the picture plane and the roaring flames in the background. The flames were etched using various techniques, including kakikezuri, flash, single-stroke etching (hatching), double-stroke etching and hikkakikezuri.

Tone Work

The background is comprised of double-layered IC Youth Y-1231 gradational tone.

A B

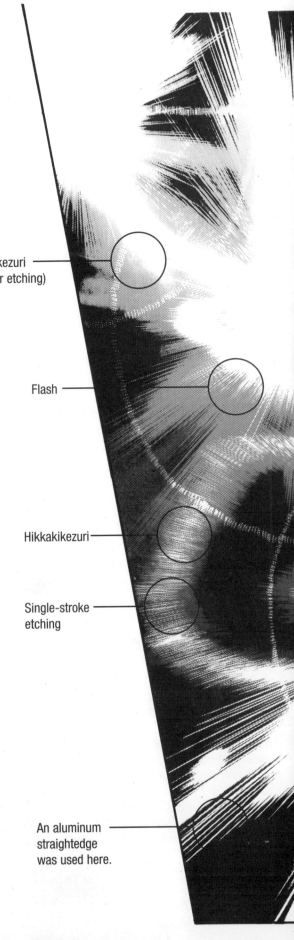

Y-1231 covers a broad range of values from white to black.

The first layer was laid in the direction shown in Figure A.

Sunakeshi kezuri (sand eraser etching)

Then, an aluminum straightedge was used for sunakeshi, flash etching, hikkakikezuri and single-stroke etching on the right side of the work.

Flash

Next, the second layer of screen tone was affixed in the direction shown in Figure B and etched in a similar fashion.

Since the intention was to overlap the two tones perfectly, a certain amount of moiré for a patch this broad was unavoidable. However, do your utmost to avoid moiré when attaching tone.

Hikkakikezuri

Single-stroke etching

In Chapter 1, I wrote that when layering, the smaller tone went on top. However, in this work, it was important that the white areas be well balanced on the picture plane. Therefore, it does not matter whether the smaller tone is on top or bottom. By the same token, when etching a broad patch, it does not matter whether the single-layered tone ends up on the top or the bottom.

Finally, the tone was cut around the figure. Use a light table when cutting.

An aluminum straightedge was used here.

IC S-444 —————

Tone Work

① First, gradational tone was affixed and areas of smoke etched.

② Next, the shading appearing inside the smoke was created using #61 and digital tone.

③ Finally, white ink was spattered throughout, and white tone was added to complete the piece.

The key was to position the shadows so that shading in the smoke was not close to the perimeters of the characters inside the smoke. This allows the characters to stand out.

IC Youth 61 —————

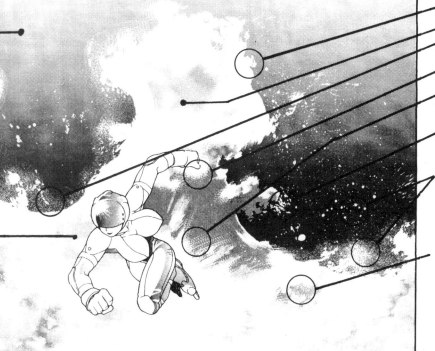

Harakezuri

IC S-959
White random-dot screen tone

Bokashi

Single-stroke etching

Hikkakikezuri

Spattering

Layering of two sheets of IC Youth 61. Here, the smaller screen tone was placed on the bottom. (Since broad patches of etching were used all over the work, it did not matter whether the smaller screen tone was placed on top of or below the larger.)

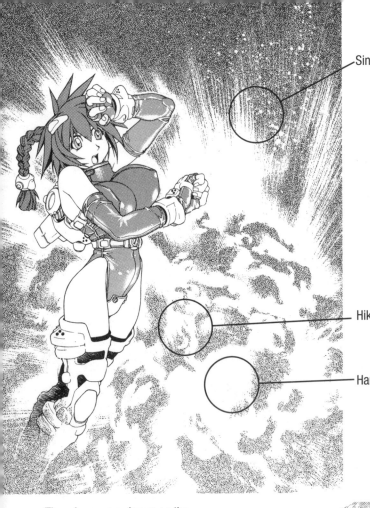

Single-stroke etching

The darkness of the screen tone here will prevent guidelines on the back of the drawing from being visible, even when a light table is used. Therefore, the guidelines were drawing on the front of the tone, and the remaining lines were erased after the tone was etched.

Hikkakikezuri, flash etching, etc.

Harakezuri

The wings were drawn on the reverse side of the sketch and then etched precisely along those guidelines. The key point was to make the sketch for the wings as precise as possible.

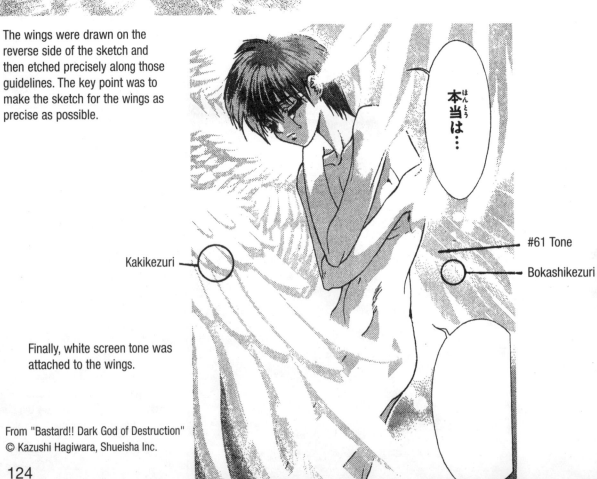

本当は…

Kakikezuri

#61 Tone

Bokashikezuri

Finally, white screen tone was attached to the wings.

From "Bastard!! Dark God of Destruction"
© Kazushi Hagiwara, Shueisha Inc.

Chapter 4
Putting on
The Finishing Touch

Using the techniques discussed thus far in this book, I
created a few sample female characters and backgrounds.
What I hope you learn from these is that the basic tone
techniques do not change, regardless of the pattern or
motif.

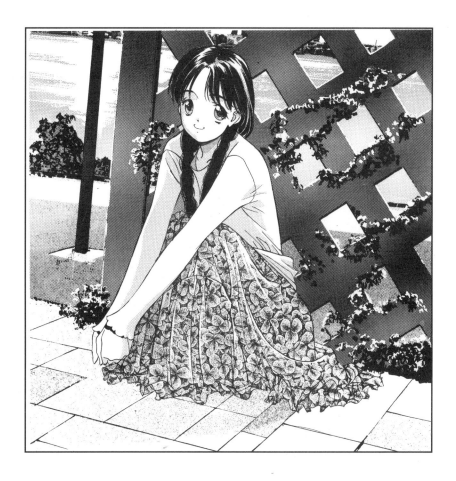

Girl in Wedding Gown

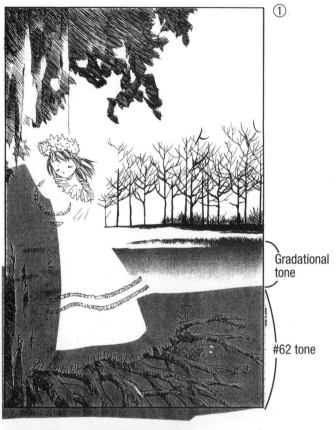

① Gradational tone

#62 tone

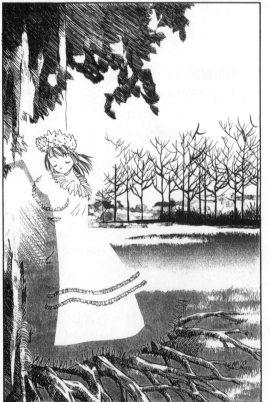

②

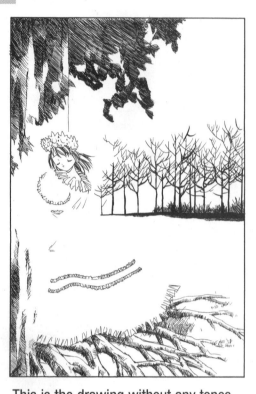

This is the drawing without any tones.

First, I sketched value-separation lines on the reverse side of the drawing for the wedding gown. I etched the tone on a light table.

Digital screen tone was used to create the forest in the background.

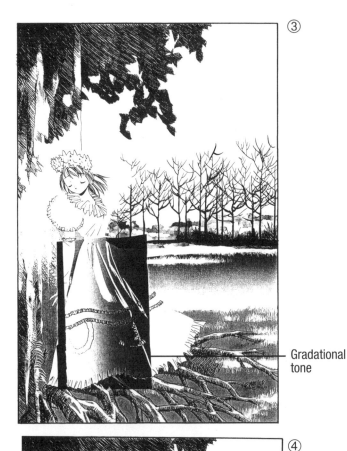

③

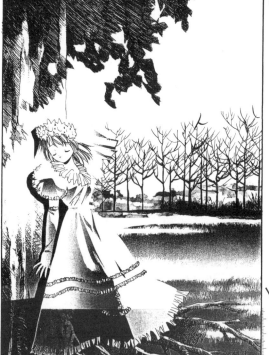

④

Gradational tone

Layered tone

I attached gradational tone on top of the dress and then penciled in creases over the tone.

As the area covered by tone increases, drawn lines begin to appear more noticeable, causing the tree leaves to stand out. So, I added tone to the leaves as well.

Adjust the Overall Composition

Hatching and other drawn lines stand out when surrounded by complicated tone work. This should be covered with #61, #62 or other tones of similiar values.

In similar fashion, I gradually added shading to the gown, and finally, used an eraser to remove penciled lines.

I layered the tone used for the ground to prevent the shading used in the gown's creases and the ground from becoming too monotonous.

No drawn lines were used for the gown's highlights (areas touched by light). I used white tone to make the highlighted frilly hem of the dress even lighter, creating an airy feeling.

The shade of the tree falling on the character is a dark tone. Bleeding and muddying of the screen tone's dots is preferable for allowing the figure to stand out.

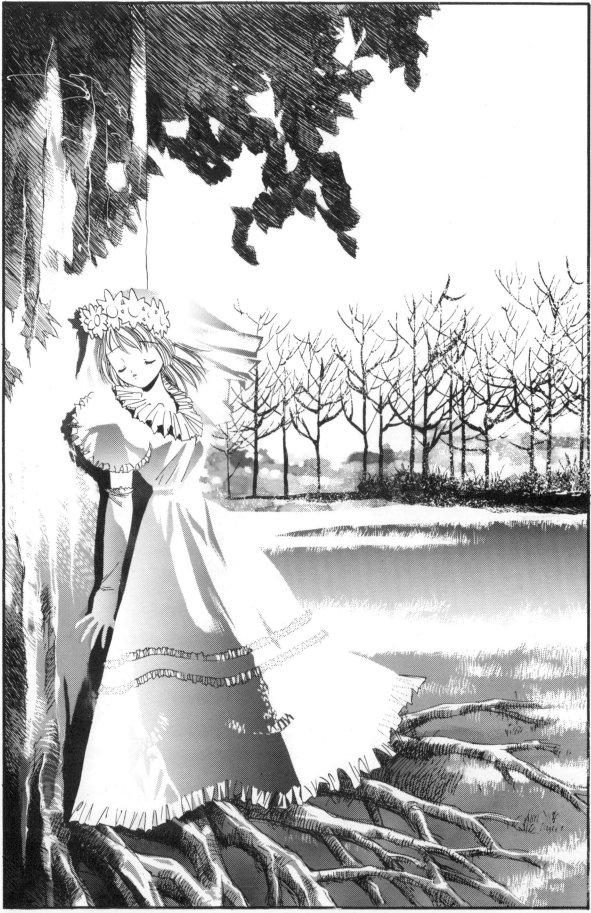

Completed work

Girl with Wings

①

I drew guidelines on the reverse side of the illustration. Since a craft knife is used to cut the tone, the guidelines should be as precise and clean as possible.

②

I then flipped the drawing over to the front and inked only those lines where pen was desired.

Illustration on the front

Sketch on reverse

③

I attached digital tone and, using a light table, cut it along the guidelines on the reverse. I also applied dot tone to the underside of the wings.

④

I etched the smoke surrounding the character. I then added shading to the clothing and etched the wings little by little.

⑥ Finished! ➡

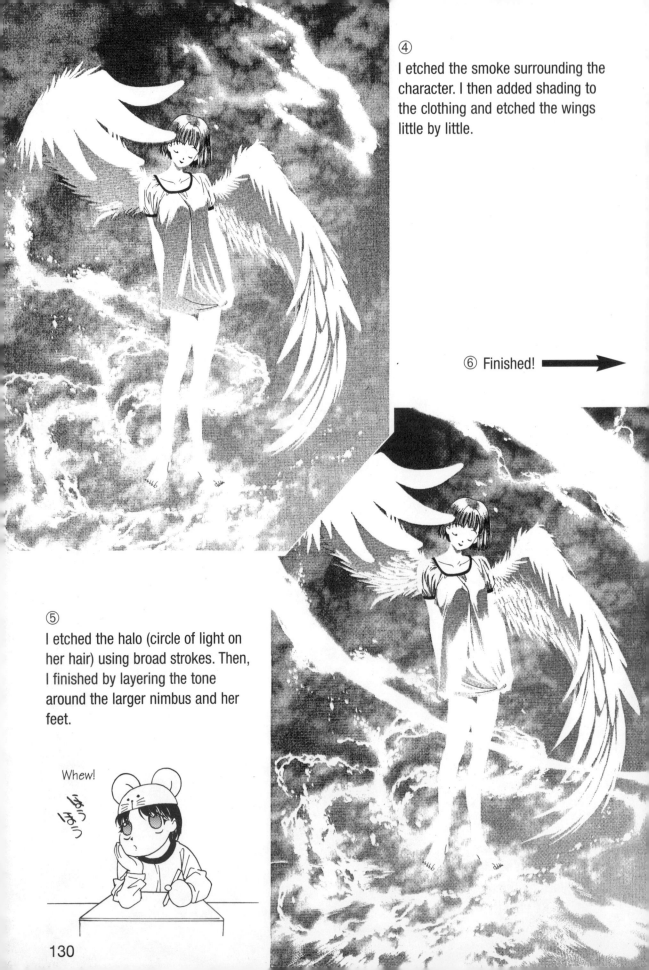

⑤

I etched the halo (circle of light on her hair) using broad strokes. Then, I finished by layering the tone around the larger nimbus and her feet.

Whew!

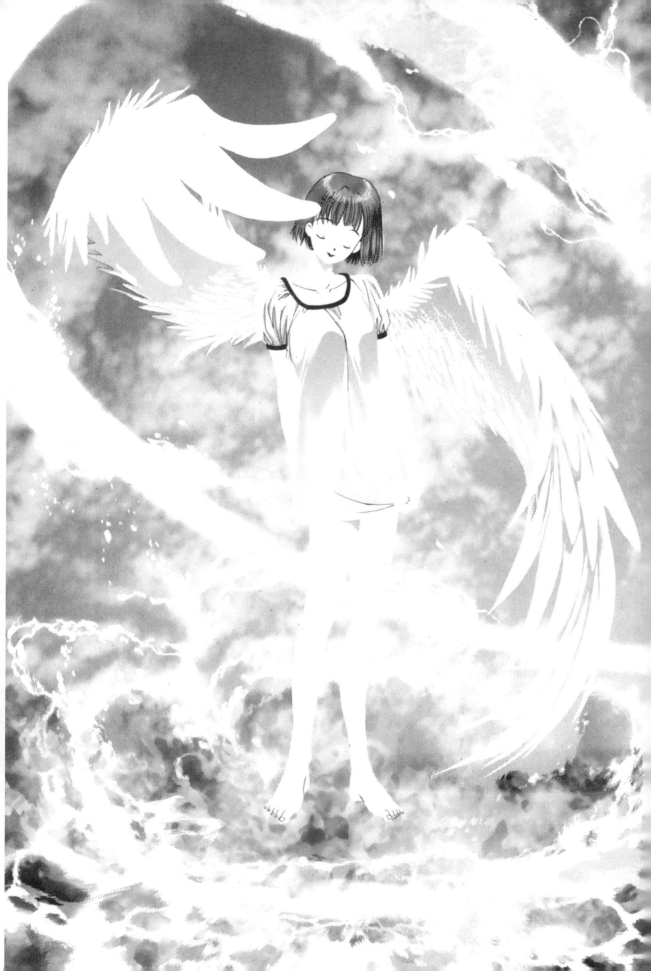

Girl Posing in a Garden

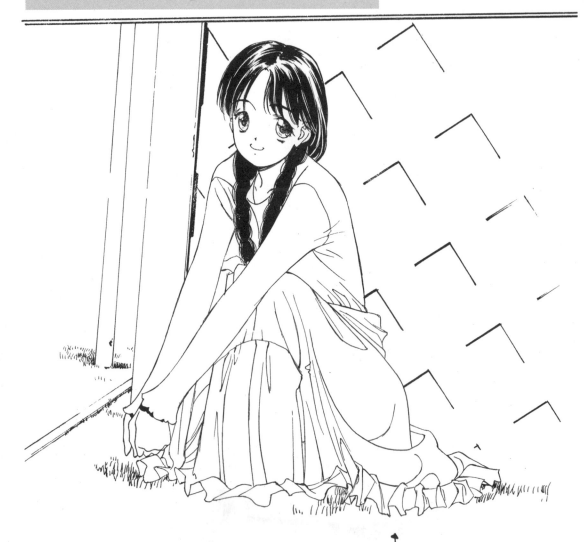

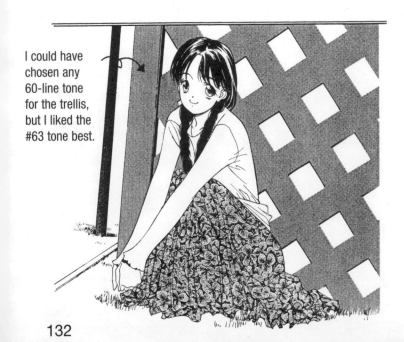

I could have chosen any 60-line tone for the trellis, but I liked the #63 tone best.

① This is a sketch based on a photograph. In the photo, the ground was tiled; however, I changed it to grass for the sketch.

② First I attached the tone for the trellis, the pole and the girl's skirt.

A #63 tone was used for the trellis's slightly darker shading.

Smudge

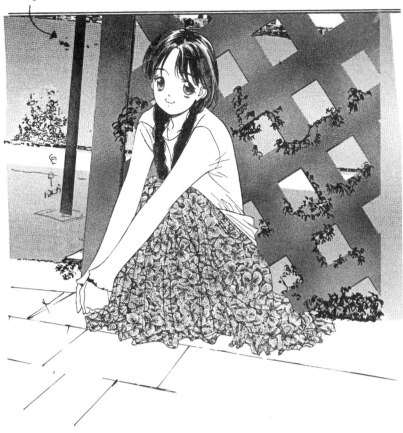

③
Here, I decided to restore the tiled ground. Although I spent a lot of time placing tone on the pole, I ultimately shortened it a bit. I also penned in the flowers on the trellis. Adjustments and corrections are easy to make at this stage.

The surface of the water is a bit smudged, but since this will be etched later, it can be cleaned up then.

④
Here, tone was added for the tile. The trellis and skirt were then etched, and white ink was used for final highlights.

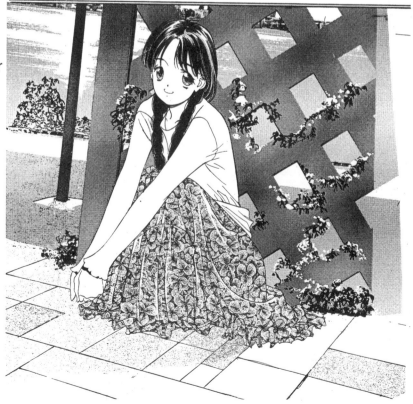

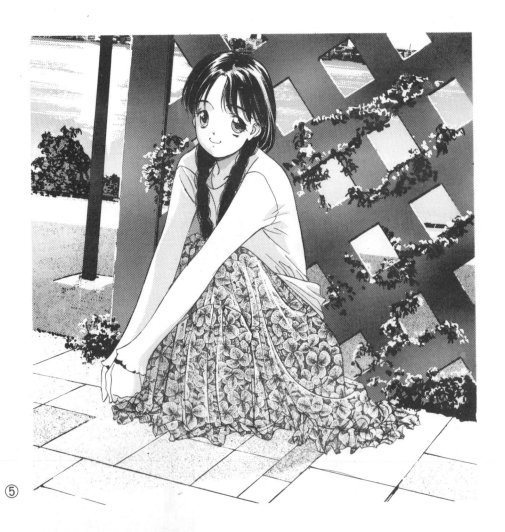

⑤

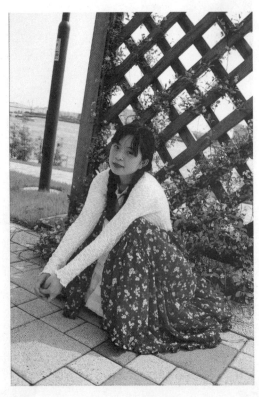

Model: Kamonohasshi

Whew! I'm done!

Final Words of Advice

Although I have introduced you to various techniques in tis book, it would be impossible for me to cover everything you need to know. But you now have a good foundation upon which to build, and all it takes it patience and practice. Just remember to keep these two things in mind:

Attach tones as you see fit.
Etch tones as you see fit.

Naturally, you should put this to practice only after having carefully learned the basics written in this book.
What is important is that the ability to draw, which constitutes the basis of creative work, will always endure, no matter how much computers may take over. The attaching and etching of screen tone are fundamentally the same as drawing. The same holds true for all artistic disciplines, be they illustration or animation.

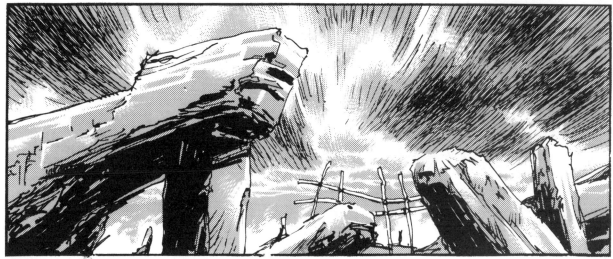